GRAN
BRETAGNA

Published by The British Council
10 Spring Gardens, London SW1A 2BN
England, UK

© The British Council 1995

ISBN 0 86355 283 8

Edited by Sophie Bowness and Clive Phillpot

Designed by Tim Harvey
Typeset in Walbaum (text) and Franklin Gothic Demi (captions)

Printed by BAS Printers

pages 4-5: The British Pavilion in 1948.

Contents

This book is dedicated to the memory of
BERNARD DENVIR 1917-1994

Foreword

Andrea Rose

This book is published to coincide with the centenary of the Venice Biennale – in itself a remarkable anniversary. International biennales and triennales of contemporary art have proliferated over the past half century – São Paulo, Sydney, Delhi, Istanbul, Ljubljana, Dakar, Johannesburg and Kwangju to name but a few – but Venice remains unique. Not only because it is the oldest; or because it takes place in such an extraordinary setting, where east meets west, ancient meets modern, land meets sea; but because over the past hundred years it has evolved into something of a miscellany, with an emphasis on pluralism and inclusiveness rather than on exclusivity and single-mindedness. To some this is a weakness, every nation going its own sweet way irrespective of theme or thesis. But diversity – and the unexpected – are special strengths of the Venice Biennale. Like the city itself, it represents a point of convergence, where local variety can be seen in an international context and national contingents add complexity to the overall view of contemporary art.

In the autumn of 1994, we invited Bernard Denvir to chronicle Britain's participation in the Venice Biennale over the past hundred years. No respecter of institutions and possibly one of the few art critics to have attended almost every Biennale since 1948, he seemed ideally suited to the job. His sudden death in December has deprived us of the opportunity to publish his work; this book is now dedicated to his memory. We should like to pay special tribute to Joan Denvir who has continued to help us in the most adverse circumstances. Particular thanks too are due to Sophie Bowness who has turned her initial research into the origins of the British Pavilion and the political manoeuvrings concerning its ownership into what now forms the main essay in this volume; and to Clive Phillpot, who took charge of the publication at a fragile stage and has seen it through to completion. Finally, thanks must go to the many unnamed staff of the British Council, both past and present, without whose dedication British art would not have played such a distinguished role in the history of the Venice Biennale.

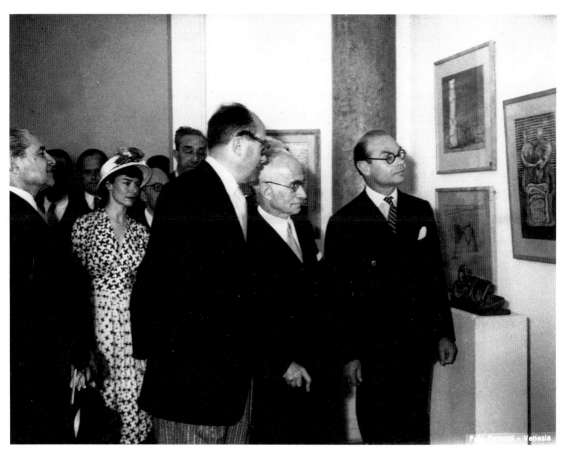

John Rothenstein (right) escorting the President of Italy, Luigi Einaudi (centre), at the inauguration of the 1948 Biennale in the Henry Moore exhibition

Introduction

Clive Phillpot

The Venice Biennale of 1938 was the first for which the British Council was responsible, but ten years passed before their next exhibition, since the onset of the second world war led first to Britain's withdrawal in 1940, then abstention in 1942, and finally to the suspension of the Biennale itself in 1944 and 1946.[1]

With the first post-war Venice Biennale in 1948, the British Council Fine Art Committee established procedures that are basically still in operation today. One of the committee, John Rothenstein, the Director of the Tate Gallery, was appointed Commissioner of the British Pavilion, and he, together with Council officers Francis Watson and Lilian Somerville, presented a retrospective exhibition of the work of Henry Moore in the national pavilion.

In this way the pattern of showing the work of either one accomplished artist in mid-career, or a small group, was established. Although Henry Moore was shown in conjunction with work by J. M. W. Turner in 1948, the practice of exhibiting the work of artists from the past, initiated from Italy, was concluded after the 1950 Biennale, at which John Constable's work was exhibited alongside that of Barbara Hepworth and Matthew Smith.

Lilian Somerville was made Director of the Fine Arts Department at the British Council a year after the success of Britain's first post-war appearance at the Biennale in 1948 – at which Henry Moore was awarded the International Sculpture Prize. She went on to become the driving force behind Britain's biennial exposure in Venice for the next twenty years, and indeed, a force at the Biennale itself.

Lilian Somerville had joined the British Council at the beginning of the war. She served briefly as Head of the Fine Art Section of the Visual Art Department after the war, before being appointed Director of the newly named Fine Arts Department in 1949.[2] Her achievements over two decades are summed up in an article by the painter Patrick Heron, published on the occasion of her retirement after the Biennale of 1970:

The 'enormously successful intervention in *promoting* British art over-

seas would never have been achieved, and certain reputations enjoyed by British artists today might well have suffered ...but for Lilian Somerville and her positively ferocious tenacity of purpose. In her person she ...combined the wily skills and tact of the supremely capable administrator with the apparently wild commitments of the avant garde artist or critic.' She was, of course, 'supported by a succession of committee members of extreme distinction'. But Lilian Somerville's accomplishments were such that she became 'the best-known and the senior member of those international meetings which determine the complexion of such events'.[3]

Although contemporary visitors will be most familiar with the series of one-artist exhibitions in the British Pavilion at recent Venice Biennales, the very early Biennales were based on different principles. For instance, in 1895 the four British members of the Committee of Patronage for the first exhibition in the series chose more than twenty British artists to exhibit in Venice (including themselves). This figure rose to over seventy in 1899, and to over one hundred and fifty in 1912.

Some readers may also be surprised to find that the first exhibition in 1895 showcased the Pre-Raphaelites. That this was no accident is made apparent in Sandra Berresford's essay in this volume, in which she documents the energetic pursuit of British representation in Venice by the organizers of the early Biennales, and the influence of the British art magazine *The Studio* in Italy.

Another facet of the story of British involvement in Venice began in 1909 with the acquisition of a national pavilion. Sophie Bowness's essay in this volume describes the origins and metamorphoses of the British Pavilion up to the time that the British Council took responsibility for national participation in 1937. She describes a very different milieu from that now obtaining, and her essay, incorporating new research and correcting former narratives, also contributes to the history of British patronage and promotion of the visual arts during the first half of this century.

In 1928 the then British Ambassador to Italy, who ably assisted the process that led to the British Government taking over responsibility for the Pavilion, noted in a letter to the Foreign Secretary that 'British cultural propaganda is limited to sport which, though undoubtably valuable does not penetrate so deeply amongst artistic nations as artistic exhibits.' He thought it important that Britain should 'express her national ideals and character' in Venice, alongside 'more self assertive nations'. However, his view that British art had 'qualities of delicacy, honesty and reserve that are bound, if made

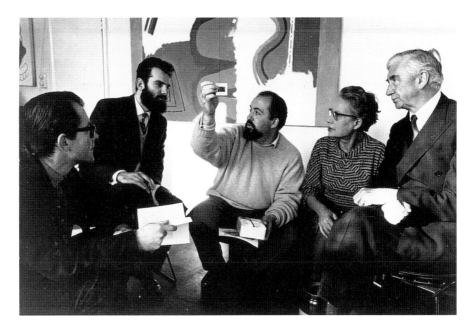

Lilian Somerville with David Thompson and Herbert Read of the 1966 Biennale Selection Committee, with Harold Cohen. Left to right: Thompson, Alan Gouk (British Council), Cohen, Somerville, Read

known, to win us friends abroad...' may cause us to wince. Nevertheless his arguments eventually helped to win the day.[4]

The chronological list of artists who have exhibited in Venice, also compiled by Sophie Bowness, is the most substantial section of this book. It should be useful in providing a single reference source for establishing which British artists – and artists of other nationalities residing in Britain – have been selected to represent the country at the Venice Biennale, and on which occasions. At the beginning of each section the names of those tastemakers who were appointed to select the participating artists have been incorporated, as well as some of the key administrative and political events in the history of Britain at the Venice Biennale.

The early years of the chronological list are augmented with images of works exhibited in Venice in those years, while more recent Biennales are documented with photographs of actual installations. Few of these have been previously published. They depict almost every facet of the interior of the pavilion, and evoke the many layers of history that are inscribed in the structure. This book will help readers to uncover these layers, and reveal that its walls have, for example, sheltered the works of Turner and Constable, Sickert and Gilman, Nevinson and Bomberg, Spencer and Nash, Moore and Sutherland, Riley and Tucker, Auerbach and Cragg, as well as many others.

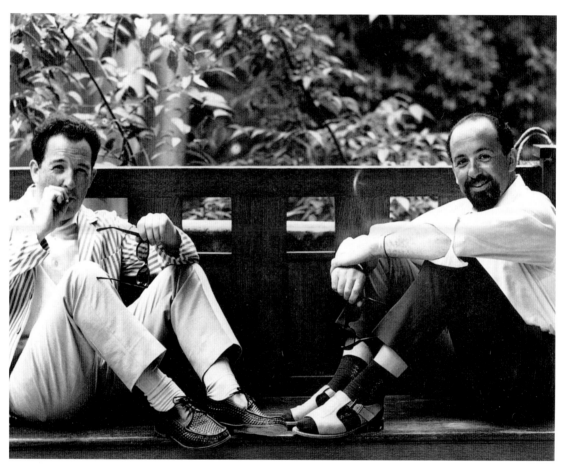

Bernard and Harold Cohen on one of the Brangwyn benches outside the British Pavilion in 1966

This string of names helps to underscore the pavilion's special place in the history of British art.

Mark Boyle, visiting Venice at a time of year very different from the bustle and heat of the summer, some months before his 1978 exhibition, evoked the beauty of the site, as well as an artist's apprehension at encountering this historical building: 'The pavilions, mostly stone, deep in fog and fallen leaves, each one inscribed with the name of its country, came into view out of the gloom, closed and shuttered in their setting of bare trees. Hungary, Israel, Rumania, Germany, The United States, Holland, Norway, Switzerland, France. In that dank setting of decay, it was like a parable of the end of the world. Peeling paint, broken masonry. Finally, up a long flight of shattered stone steps to the British Pavilion. It was beautiful, the light was sort of ethereal, it was a marvellous space and it was totally daunting. We came away excited but appalled.'[5]

NOTES

[1] This introduction is informed by the work of Bernard Denvir, who was writing an essay for this publication at the time of his death in December 1994.

[2] In the course of 1948 the Fine Art Section and the Visual Art Department became the Fine Arts Section and the Visual Arts Department.

[3] Patrick Heron, 'Lillian Somerville', *Home and Abroad*, no. 19, December 1970, pp. 56-58. Since Lilian Somerville's retirement, there have been five Directors of the Fine Arts Department, latterly Visual Arts Department: John Hulton (1971-75), Gerald Forty (1975-80), Julian Andrews (1980-86), Henry Meyric Hughes (1986-93) and Andrea Rose (1993 to date).

[4] Letter to Austen Chamberlain, 7 August 1928, BT 60 30/4, Public Record Office, Kew.

[5] J. L. Locher, *Mark Boyle's Journey to the Surface of the Earth*, Stuttgart & London: Edition Hansjörg Mayer, 1978, p.225.

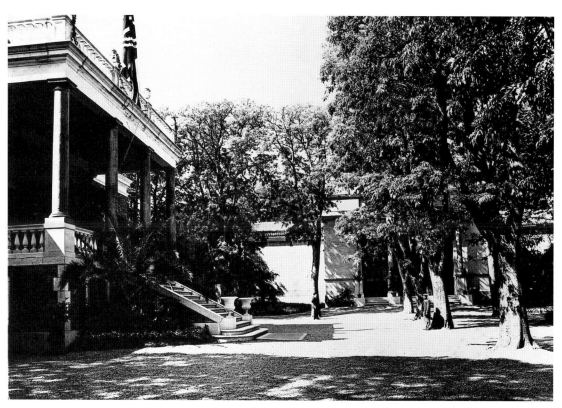

Fig. 1 The new Pavilions of Great Britain and Bavaria at the 1909 exhibition

The British Pavilion
before the British Council

Sophie Bowness

 On 22nd April 1909 the British Pavilion was opened on the occasion of the eighth Venice Biennale, the initiative of a small private committee of British enthusiasts acting on the encouragement of the Secretary General of the Biennale, Antonio Fradeletto. Following the example of the Belgian Pavilion in 1907, the British was one of three foreign pavilions inaugurated in 1909, the Hungarian and the Bavarian (from 1912 the German Pavilion) being the other two.[1] (Fig. 1) The early history of the Pavilion before its transfer in 1932 to the control of the Department of Overseas Trade and then in 1937 to the newly formed British Council was to be one of repeated rebuffs: the anomalous situation of a national pavilion entirely dependent on private patronage continued for over twenty years before Government support finally came.[2]

Late in 1908 Fradeletto had arrived in London on behalf of the Municipality of Venice with the mission to establish a permanent pavilion for British art at the Biennale. The painter John Lavery, Fradeletto recalled, was "the very first Gentleman ...to take an active interest in the matter. He wrote indeed to the Rt. Hon. Earl of Plymouth, and introduced me to Mr. Grosvenor Thomas. This latter Gentleman, in his turn, interested Mr. P. G. Konody in the matter; and he had the opportunity of securing the worthy co-operation of Mr. M. B. Huish... [To all involved] England will undoubtedly be grateful for having provided the Fine Arts of the United Kingdom with a dignified permanent Home in an important artistic and historic place abroad; Italy is already very thankful to them for having chosen the City of the Lagoons as the unprecedented Guardian of what will be the precious property of their Great Nation."[3]

Under the terms of the Convention agreed between the British Committee and the Municipality of Venice and signed early in 1909, the Pavilion was purchased from the Municipality for £3,000 and the land on which it stood was leased to the Committee for a nominal rent of ten shillings a year.[4] The Committee reserved the right (never exercised) to name the building 'The Ruskin Memorial', in homage to Ruskin's intimate association

with Venice. It was to appoint an artis-tic sub-committee, consisting of not more than two painters and a sculptor, for the selection and hanging of the works of art.[5]

The money for the Pavilion was provided by a single benefactor, Sir David Salomons.[6] He made the gift in order that, in his words, "English artists shall not be placed in a worse position than foreign artists at an important International Exhibition"; that they may "extend their means of becoming known and earning their livelihood"; and that "their Art may be improved by competition of a healthy

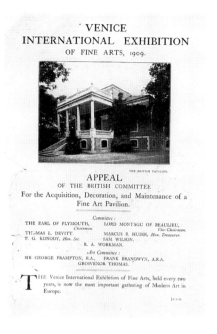

Fig. 2 Appeal of the British Committee, January 1909

character."[7] The Committee launched a public appeal to raise further funds for the decoration and maintenance of the Pavilion.[8] (Fig. 2)

Only a few months remained until the exhibition was due to open: construction of a new Pavilion was therefore impossible, and Fradeletto offered the Committee a building which had been constructed as a Café-Restaurant in 1887 by the chief engineer of the Comune of Venice, Enrico Trevisanato, for the Esposizione Nazionale Artistica – a direct antecedent to the Biennale first held eight years later – which took place in the Giardini in the summer of that year.[9] (Figs. 3 and 4) The commanding situation of this former Café, on the Montagnola (hillock) at the head of the broad lateral avenue, particularly commended it.

The conversion of the Café was undertaken by the British architect E. A. Rickards.[10] His alterations to Trevisanato's sober classical building were rela-tively modest, consisting principally in the creation of additional exhibition space at the back. The rear loggia, which mirrored that at the front, was enclosed to create a new gallery, with large windows filling in the space between the four outer columns. (Fig. 5) In addition, two rooms on the corners at either side of this long gallery were constructed.[11] A wider entrance door was made, with a flat lintel replacing the existing decorative one; the two windows on either side of it were blocked in, and balconies on either side of the loggia were added. A marble tablet inscribed 'GRAN BRETAGNA' was fixed

Fig. 3 Plan of the
1887 Esposizione
Nazionale Artistica
held in the Giardini

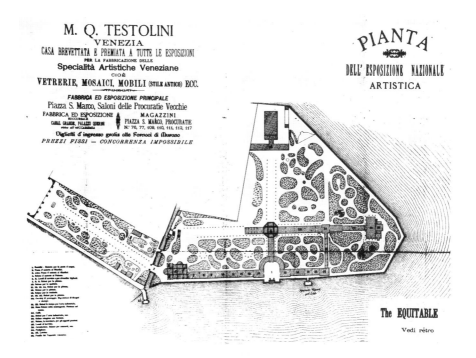

Fig. 4 Sketch of the
entrance to the 1887
exhibition

over the entrance. (Figs. 6, 7 and 8) The Pavilion now comprised six galleries, five smaller ones flanking the large central room. (Fig. 9) It has remained essentially unchanged since this date.[12]

The practice of appointing national commissioners to organise their country's representation was already established at the Biennale. In 1905 for the first time there were commissioners for the English room created in the central Pavilion – the artists Walter Crane and Alfred East and the sculptor

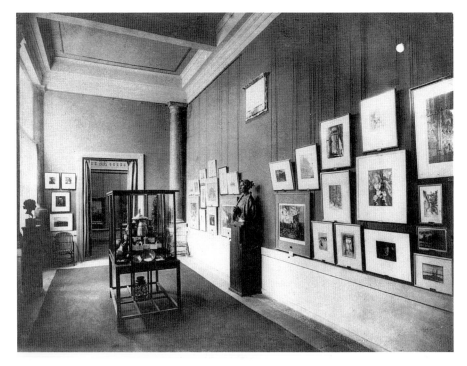

Fig. 5 The long gallery of the Pavilion during the 1909 exhibition, with Alfred Drury's *The Prophetess of Fate* (plaster version) on a pedestal designed by Frank Brangwyn. Above is the wall tablet which recorded Sir David Salomons' gift of the Pavilion

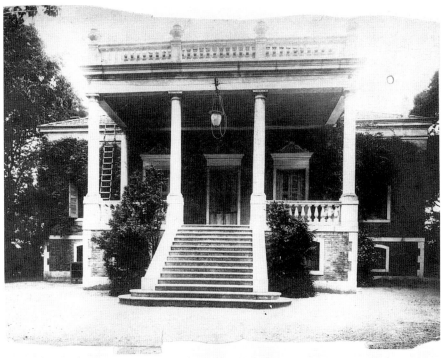

Fig. 6 The Pavilion as it was at the beginning of 1909, before Rickards' alterations

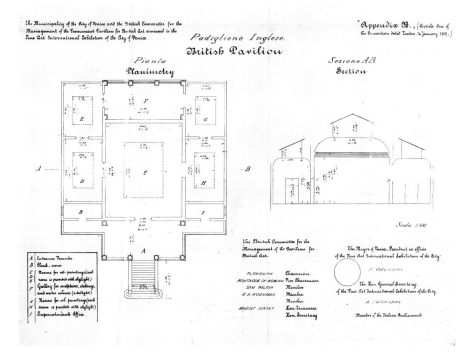

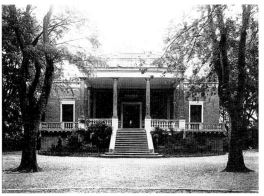

George Frampton – who were invited by the Biennale authorities to make the selection of works.[13] (Figs. 10 and 11) At the time of the preparations for this exhibition, the Venetians had urged an approach to the British Government for a grant towards the expenses of the English section at the Biennale: "At last it is the question of a very little sum for such a great and rich country!" Fradeletto wrote to East in December 1904.[14] The committee's request was, however, rejected by the Treasury in March 1905 on the grounds that Government grants were confined to exhibitions originated by the Government and held in the capital of the country concerned: "An Exhibition in Venice under the auspices of the Municipality of that city cannot be held to fulfil these conditions, and the Chancellor of the Exchequer is not aware of any special circumstances which would in this case justify him in making a departure from the ordinary rules."[15] Another attempt

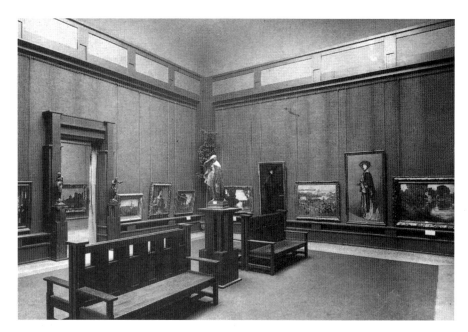

Fig. 9 The central room of the Pavilion in 1909, with Lavery's *Polyhymnia, Market at Tangier,* and *Mrs Vulliamy,* George Frampton's *La Belle Dame sans Merci* (plaster) in the centre of the room, and James Guthrie's portrait of *Mrs John Warrack* on the left-hand wall

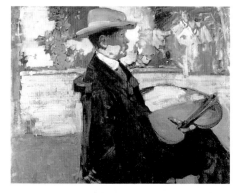

Fig. 10 *Portrait of Alfred East* by Frank Brangwyn (National Portrait Gallery)

was made in 1909-10 when Marcus Huish, Honorary Treasurer of the British Committee, approached the Exhibitions Branch of the Board of Trade (responsible for organising official British participation in exhibitions abroad and at home) with the request that the Government take over the Pavilion – the first of many such approaches in the coming years.[16]

The 1920s were the most troubled period in the Pavilion's history. Reliant on uncertain resources and temporary expedients, its continued existence was precarious. Britain's non-participation in the Biennale of 1920, the first since the outbreak of war, was the cause of much ill-feeling and mutual reproaches, arising in part from the fact that the works shown in the Pavilion at the 1914 Biennale had still not returned home: when war had broken out during the exhibition, the British works had remained in Venice, moving later to Rome for their safety.[17] (They finally arrived back home in June 1920, some damage having been incurred.) Now Marcus Huish, who had played an important organising role in the pre-war Biennales, asked whether the Pavilion could

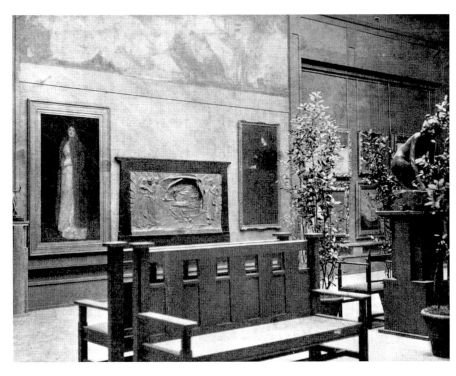

Fig. 11 The English room, 1905, with two of Brangwyn's benches and a pedestal on which is William Goscombe John's bronze *The Elf*; on the wall behind is George Frampton's bronze bas-relief *So He Bringeth Them Unto Their Desired Haven*, on the right William Mouat Loudan's *The Black Hat* and on the left Maurice Greiffenhagen's *Portrait of Mrs Greiffenhagen*. Above is Brangwyn's mural *The Steelworkers*

Fig. 12 William Roberts, *The Art Critic. P.G. Konody*, 1920, private collection

revert on this occasion to its former use as a restaurant to avoid remaining empty. In the event it was taken over by the American section, becoming for the duration of the exhibition the Padiglione degli Stati Uniti.[18]

With the death or resignation of many of the members of the British Committee the art critic P. G. Konody, who had been Honorary Secretary to the Committee since its inception, became the principal animator of the Pavilion, and remained so throughout the 1920s.[19] (Fig. 12) At this low point Konody, like Huish before him, approached the Exhibitions Branch of the Department of Overseas Trade in the summer of 1921 with the request that it should take over the Pavilion. On behalf of the Committee he asked for £1,000 for its purchase.[20] His proposal was rejected; citing Italy's poor economic situation and the unfavourable exchange rate, Alfred Longden (who was to play a significant role in organising the British representation at Venice in the 1930s) made a startling suggestion to Colonel Henry Cole, Director of the Exhibitions Branch: "Under the circumstances would it not be a sounder plan to consider the

possibility of a British art centre in, say, a prosperous Scandinavian country rather than in a place like Venice."[21] Government ownership of the Pavilion was Konody's preferred solution, but in the event of rejection he also wrote to the Biennale authorities to ask "whether there is any possibility of the Municipality of Venice buying back the Pavilion at a reduced price."[22] The financial position of the Committee was such that it also offered the Pavilion to Spain at this time.[23]

When none of these proposals was accepted, Konody placed the Pavilion in the hands of the Venetians for the 1922 exhibition, and they invited Frank Brangwyn, so closely involved in pre-war Biennales, to act as commissioner. Lack of time prevented the realisation of Brangwyn's original desire, in his words, "to have a fine display of decorative art, to make each room complete with furniture, carpets and wall decoration, a music room, a dining room, etc." (a revival of the idea of his earlier decorative ensembles at the Biennale, discussed below).[24] The works selected by Brangwyn were so weak, however, that, according to Konody's account: "Bourlet's, the packers, thinking that such an exhibition would be injurious to British Art, asked me to inspect the works before they were sent off, and to see if I cannot do something to make the show more creditable. At the eleventh hour I stepped in and secured some 30 or 40 pictures ... which saved the British section from being a complete fiasco and added to it just a note of distinction."[25]

For the 1924 Biennale the British Committee was re-formed, and the British section organised through the Faculty of Arts – a federation of creative artists which aimed to promote public interest in the arts – and financed by its President, Lord Leverhulme.[26] On his return from hanging the works in the Pavilion, the painter and member of the selection committee that year, Kennedy North, made his own appeal in *The Observer* for the Government to purchase the Pavilion: "The cure for the moribund state into which this important art matter has been allowed to lapse is in the Government waking up to what should be its responsibilities in International Exhibitions of British Art." Private munificence, with its unreliability, should no longer be necessary.[27] Konody again approached the Department of Overseas Trade, and his petition was again rejected.[28] He and the sculptor Frank Dobson organised the 1926 British section, and Dobson accompanied the King of Italy round the Pavilion at the official opening.[29]

In a letter to *The Times* of 31 December 1927, the British Committee appealed to the public for a fund of £6,000: British resources had been

exhausted at the 1926 Biennale, and another request for Government support earlier in the year had been rejected.[30] The absence of a British representation, the Committee stated, would be "a disastrous calamity when one considers the importance of this great international art market"; "...it is a matter involving the whole prestige of British art that the British pavilion at Venice should be made a permanency, so that the work of our painters may maintain its rightful place in Europe... Our artists have nothing to fear from comparison with artists of any other nation. To deny their works a place in the biennial exhibitions at Venice would be a national blunder."[31] The response to this appeal was, however, disappointing.

Further pressure came in March 1928 when a distinguished group representing the British Confederation of Arts addressed a letter to Sir William Clark, Comptroller General of the Department of Overseas Trade, urging the Government to take over the Pavilion; the signatories included Sir George Clausen, Sir John Lavery, Sir Frank Dicksee, Sir William Orpen, Charles Ricketts, Charles Shannon, Augustus John, Roger Fry, Frank Dobson, Henry Tonks, William Rothenstein, Sir Charles Holmes, Sir Herbert Baker, Sir Giles Gilbert Scott, and George Bernard Shaw.[32] They argued that the present situation in Venice was "not creditable either to British Art or, what may well be more important, to British prestige and our relations with Italy in general. When in every gallery Ministers of the different nations to which they belong are waiting to receive the visit of the King of Italy, it seems unfortunate, to say the least, that in our Pavilion alone some make-shift arrangement is all that can be effected." Other Pavilions enjoyed the support of their governments and the British representation should be placed on a parity with them. America was apparently eager to take the building if Britain were to vacate it.[33] The letter was followed up by a deputation on 24th April.[34] The subject was now receiving serious consideration from the Government, but progress was slow. There was an acknowledgement within the Department that although it had previously confined itself to exhibitions connected directly with manufacture and never fine arts, "it is possible for this purpose to regard the production of British pictures as a British industry."[35] The amount of money involved was not large, but the proposal raised questions of policy: C. L. Stocks of the Treasury commented that it would be "a most revolutionary change" for the Government to take over the Pavilion. There was no precedent for its managing any permanent exhibition of paintings – or anything else – for sale, and if one were created "it might lead to a demand for similar Art Exhibitions at

Government expense, e.g. in Paris or New York or South America; and also to an increased pressure for State aid to e.g. opera. Can the State aid one picture exhibition and not others, and one form of art and not others?"[36]

The British presence in Venice in 1928 was due entirely to the generosity of Sir Joseph Duveen, and the exhibition was mounted by his national organisation, British Artists' Exhibitions.[37] He continued to support the Pavilion financially over the next six years with gifts of £150 a year.

A proposal that the Contemporary

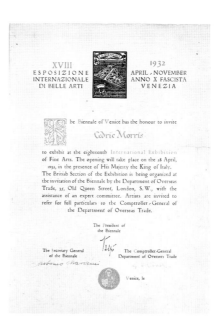

Fig. 13 The official invitation to Cedric Morris to exhibit, 1932

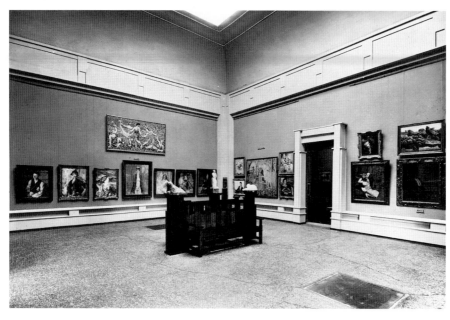

Fig. 14 The Central Room of the British Pavilion in 1932, including paintings by Duncan Grant (*Long Decoration – Dancers*, 1934), Ambrose McEvoy, Ethel Walker (including *The Three Graces*, 1928 and *Lady with a Fan*) and Gerald Kelly, and sculptures by John Skeaping

Art Society should take over the Pavilion was made in 1929 by C. L. Stocks of the Treasury, acting confidentially through Edward Marsh and H. S. Ede:[38] at a meeting on 4th July, its Executive Committee gave very careful consideration to the matter but decided that the Society's funds were insufficient to undertake the responsibility.[39]

The advocacy of the Pavilion's cause by the British Ambassador to Italy,

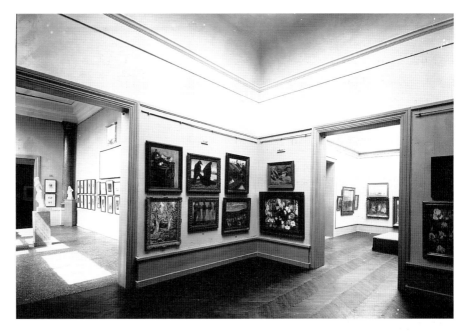

Fig. 15 The British Pavilion in 1932: paintings by Duncan Grant (including *Dancers*, c. 1910-11) and Cedric Morris (including *Ducks in Flight*, c. 1924), sculptures and works on paper by Eric Gill

Sir Ronald Graham, was an important factor in the eventual acceptance by the Government. Writing to the Foreign Secretary in August 1928, Graham set out the reasons, political and commercial, in its favour and argued that Britain's absence would be interpreted as "a sign of national indifference to art."[40] When at the 1930 Biennale the Pavilion was placed under Government patronage for the first time (Ramsay MacDonald's second Labour Government was then in power), Britain was officially represented at the opening by Graham.[41]

Then, late in 1931, the Government agreed to accept responsibility for the Pavilion, a decision which took effect in January 1932. The British Committee formally relinquished ownership in favour of the Government, and Konody's twenty-year involvement in the Biennale ceased.[42] In 1932 for the first time the British section at the Biennale was organised by a Government department, the Department of Overseas Trade. In a telegram to the Secretary General of the Biennale, Antonio Maraini, the Comptroller General of the Department, Sir Edward Crowe, declared that this Biennale added "a new and splendid page to the story of Italo-British artistic relations".[43] At the urging of the Biennale authorities the very large numbers of artists exhibited began to be reduced, from ninety seven shown in 1930 to twenty five in 1932 and down to just seven in 1938. (Fig. 13[44] and Figs. 14, 15)

The Department of Overseas Trade again organised the representation in 1934, but Britain did not participate in the 1936 Biennale due to complications

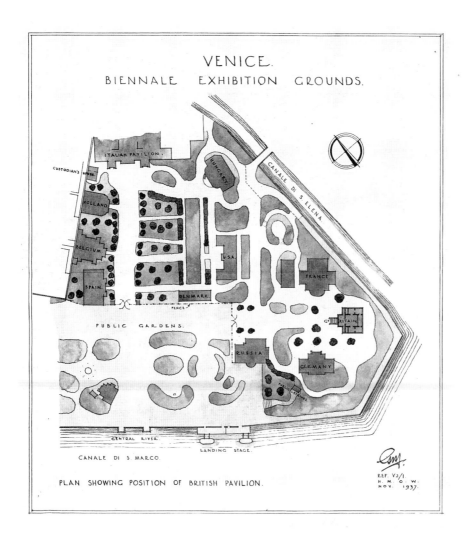

Fig. 16 The Giardini
in November 1937

arising from the transfer of the organisation of the exhibition to the British Council, and to the breach with Italy caused by Mussolini's invasion of Abyssinia.[45] In 1937 the British Council took over responsibility for British participation in the Biennale, and organised the Biennale for the first time in 1938.[46] (Fig. 16 [47] and Fig. 17) The Council's Fine Arts Committee, formed in 1935 to promote knowledge and appreciation of British art abroad by organising loan exhibitions of the fine arts, took over the role formerly played by the Exhibitions Branch of the Department of Overseas Trade;[48] Alfred Longden, who as Art Adviser to the Department of Overseas Trade had played an important part in organising the British sections in 1932 and 1934, was the British Council's commissioner for the exhibition.[49]

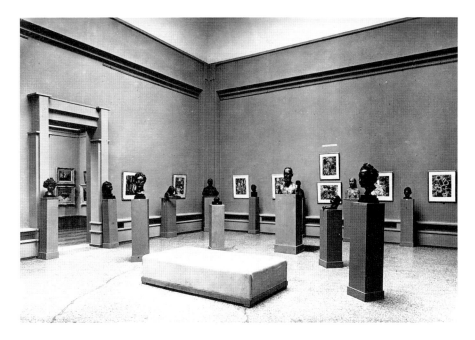

Fig. 17 The British
Pavilion in 1938:
sculptures and water-
colours by Jacob
Epstein, and works
by Christopher Wood
in the far room

The shift from private benefaction by rich patrons to governmental support for the arts in Britain which was to be dominant after the Second World War was mirrored in the history of the British Pavilion.[50] One of the first national pavilions, it yet remained in private ownership for many years, and during the long search for official status Longden's description of it in 1929 as "this unfortunate pavilion" often seemed justified.[51] A singular case amongst the foreign pavilions, it alone was not built to serve as an exhibition space and was already over twenty years old when taken over, yet has remained remarkably unaltered since that time.[52]

Frank Brangwyn at the Biennale:
Decorative schemes for the Sala Inglese

For the 1905 Biennale Frank Brangwyn, a favourite at the exhibition, was invited by Antonio Fradeletto to design a decorative scheme for the English room in the central Pavilion. Adapted in part in 1909 for the British Pavilion, Brangwyn's modified design was an important feature of the interior until the Second World War, and his oak benches are still used today. (See Figs. 9, 11, 14, 15 and 20, and pages 14 and 113.)

Brangwyn's intention was to create a sympathetic and harmonious

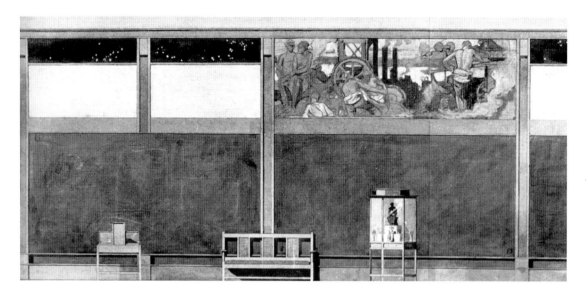

setting for the works which were to be exhibited in the room. He was responsible for every aspect of the design, from the murals to the wall surfaces and the furniture. (Fig. 18)[53] "In the arrangement of this room", Brangwyn said, "I have endeavoured to cause the person who enters it to feel the presence of a quiet richness, a certain sense of harmony, without being able for the moment to give any reason for it... The scheme of colour is what I believe to be the very best for the purpose. The greater part of the walls are of a grey buff, which, as a background for the pictures, will neither take away from the subtleties of tone, nor force into prominence any particularly strong notes of colour occurring in the works shown."[54]

A blue frieze spotted with silver ran round the upper part of the room, broken by four murals, *The Steelworkers*, *The Navvies*, *The Potters*, *The Blacksmiths*, representing British industrial life.[55] (Fig. 19) The rectilinear furniture designed by Brangwyn which complemented the dominant geometry of the whole included four oak benches, pedestals for sculpture, cabinets, screens, a table, chairs, a bureau and table lamps. Together with carpentry in

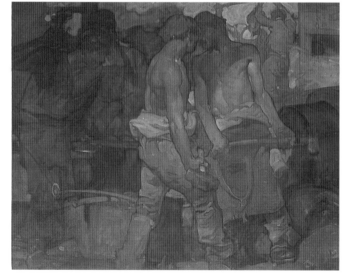

Top: Fig. 18 Sketch by Brangwyn for the 1905 Sala Inglese (from *The Studio*)

Above: Fig. 19 Frank Brangwyn, *Blacksmiths*, 1905, oil on canvas, 165.1 x 205.7 cm, Leeds Museums & Galleries, City Art Gallery

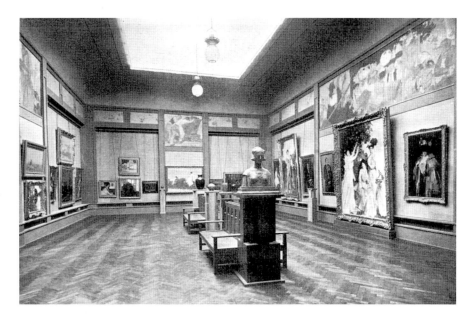

pine-wood for the walls, it was made by the firms of J. S. Henry of London and Pasqualin and Vienna of Venice.[56] (Fig. 11)[57]

Awarded a gold medal (see illus. p. 61) and a diploma, Brangwyn wrote to Antonio Fradeletto to express his gratitude: "It is a great thing that Venice the birthplace of most that is noble in painting is doing so much for Art today, thus conferring in our own time the great honour of connecting the modern artist in however a humble way with its splendid past."[58] (cf. Plates for Biennale of 1903, the medal designed by Harris) The four paintings shown in 1905 were presented in 1906 to Leeds City Art Gallery by Sam Wilson, and installed there together with a fifth, *The Spinners*, specially commissioned.[59]

For the 1907 Biennale Brangwyn was again invited to design the English room. The same space was allocated and Brangwyn created a second set of murals, *Venetian Commerce*, *Venetian Serenaders* on the theme of modern Venetian life, and *Agricultural Labourers* and *Steelworkers*, to fill the same places as those of 1905, while retaining the other features of the earlier room.[60] (Fig. 20)[61]

Under the Convention of 1909 the Venice Municipality presented the British Committee with the furniture and carpentry designed by Brangwyn to use in the British Pavilion. Brangwyn oversaw their adaptation to the new setting. (Figs. 5 and 9) The central room (smaller than the Sala Inglese) thus resembled a simplified version of the earlier ensembles and the distinctive character of the Sala was carried forward to the new Pavilion.[62]

NOTES

Note: the archival material used here is found at the Archivio Storico delle Arti Contemporanee, Venice (abbreviated as ASAC) and at the Public Record Office, Kew (PRO).

[1] The 1909 Biennale had the highest attendance figures recorded to date (457,960).

[2] The majority of other governments supported their national sections; the Belgian and Hungarian pavilions, for example, were backed from the start by their governments.

[3] Letter from Fradeletto to Grosvenor Thomas, P. G. Konody and Marcus Huish, 11 January 1909 (Fondo Storico ASAC, Serie Scatole Nere Padiglioni: Gran Bretagna, busta n. 22, "Convenzione – Padiglione Inglese"). They replied that the success of Fradeletto's London mission was "largely due to your untiring efforts and never failing tact." (Letter to Fradeletto of 13 January 1909.)

Lavery, who had been on the jury for the 1899 Biennale, had been awarded a gold medal in 1903, and was the recipient of the Cross of Chevalier of the Royal Order of the Crown of Italy, was soon to be invited by Fradeletto to present a retrospective of his work in the central Pavilion at the 1910 Biennale. The paintings exhibited by him in 1909 can be seen in the photograph of the central room of the British Pavilion (Fig. 9).

[4] On the Convention see Fondo Storico ASAC, Serie Scatole Nere Padiglioni: Gran Bretagna, busta n. 10 and busta n. 22. It was confirmed in 1914 (see WORK 10/403; PRO, Kew).

Members of the British Committee are included in the *Chronology* (see pp. 51-143).

[5] Artists continued to make up the selection committees until 1932.

[6] Salomons (1851-1925), 2nd Baronet, was an engineer, former Mayor of Tunbridge Wells, a Director of the South-Eastern – and later the Southern – Railway and a pioneer of motoring in Britain (like Lord Montagu of Beaulieu, Vice-Chairman and later Chairman of the British Committee from 1909 until his death in 1929, who probably enlisted Salomons' support): in 1895 Salomons organised the first motor show in Britain, and formed Britain's first motoring organisation, the Self-Propelled Traffic Association. He owned a collection of modern art. In recognition of his generous gift of the Pavilion he was presented with the Order of the Crown of Italy. See Albert M. Hyamson, *David Salomons*, London, 1939.

The Pavilion in fact cost only a third of Salomons' £3,000 gift: the balance was used for the enlargement and decoration of the building.

[7] Cited in the 'Appeal of the British Committee for the Acquisition, Decoration, and Maintenance of a Fine Art Pavilion', 1909 (BT 60 30/4; PRO, Kew).

[8] 'Appeal of the British Committee', op. cit. Konody recalled in 1924 that £1,500 was raised from a tombola for which a number of artists provided pictures (BT 60 30/4).

A letter related to the 'Appeal' asking the public for funds was published in English newspapers such as *The Times* on 15 January 1909. See also William Michael Rossetti, 'British Art in Venice', *The Athenaeum*, London, no. 4239, 23 January 1909, p. 110.

The Chairman of the Committee, the Earl of Plymouth, helped to finance the British section before the war (BT 60 30/4).

[9] Trevisanato designed the exhibition buildings together with the young architect Raimondo d'Aronco.

The Café-Restaurant replaced an earlier Café built in 1812 by Giannantonio Selva. (See Fig. 21.) The construction in 1907 of a new refreshment building had made Trevisanato's Café redundant.

Trevisanato went on to design the structure – but not the façade – of the Palazzo dell'Esposizione built for the first Biennale in 1895. He held the post of chief engineer between 1891 and 1903. (Archival material on Trevisanato is held in the Comune di Venezia's Archivio Celestia.)

Fig. 21 Detail from a drawing by Raffaele Mainella showing the first Café-Restaurant shortly to be replaced by Trevisanato's building. (From: *Esposizione Nazionale Artistica Illustrata*, 23 March 1887)

On the history of the building see Gian Domenico Romanelli, *Ottant'anni di architettura e allesti menti alla Biennale di Venezia*, Venice, 1976 (extracted from *La Biennale di Venezia. Annuario 1975. Eventi del 1974*, a cura dell'Archivio Storico delle Arti Contemporanee, Venice, 1975, pp. 645-668, and *La Biennale di Venezia. Annuario 1976. Eventi del 1975*, 1976, pp. 838-896); Marco Mulazzani, *I Padiglioni della Biennale. Venezia 1887-1988*, Milan, 1988, p. 50; Romolo Bazzoni, *60 Anni della Biennale di Venezia*, Venice, 1962; and Paolo Rizzi and Enzo Di Martino, *Storia della Biennale, 1895-1982*, Milan 1982. All, however, contain inaccuracies concerning the Pavilion.

[10] In partnership with H.V. Lanchester, Edwin Alfred Rickards (1872-1920) was the architect of buildings such as Methodist Central Hall, Westminster (1905-11). See the obituaries in *The Builder*, vol. CXIX, no. 4048, 3 September 1920, and no. 4051, 24 September; and *The Art of E.A. Rickards. Comprising a Collection of his Architectural Drawings, Paintings, and Sketches*, London, 1920 (in his Personal Sketch of Rickards here, Arnold Bennett concluded: "The two most interesting, provocative, and stimulating men I have yet encountered are H.G. Wells and E.A. Rickards."). Rickards was also an artist, illustrating for example P. G. Konody's *Through the Alps to the Apennines*, London, 1911.

[11] BW 40/42 (PRO, Kew).

[12] It has undergone restorations and internal alterations of course.

[13] In 1907 Frank Brangwyn acted as sole commissioner for England.

The designs he made for the English rooms in 1905 and 1907, re-used in the British Pavilion in 1909, are discussed on pp. 29-31.

[14] "We should be very obliged if you would try to obtain a statement of financial assistance from the English Government, like to the statements of France, Germany and Hungary." Letter from Antonio Fradeletto to Alfred East, 27 December 1904 (Fondo Storico ASAC, Serie C L 53, "Sala Inglese").

[15] "He [Austen Chamberlain] is therefore of the opinion that no useful purpose could be served by his receiving the Deputation" (proposed by the committee to put their case). Letter from George H. Duckworth, Chamberlain's Secretary, to East, Crane and Frampton, 7 March 1905 (Fondo Storico ASAC, Serie Scatole Nere Padiglioni: Gran Bretagna, busta n. 9, "1905 Biennale. Mostra dell'Inghilterra").

[16] BT 60 30/4. A report on the question was prepared by Sir Isidore Spielmann, Director of Art, Board of Trade (Exhibitions Branch). The Branch had been formed in 1908. An example of an exhibition in which official participation was considered desirable was the Rome Esposizione Internazionale di Belle Arti in 1911, for which Spielmann acted as British Commissioner-General.

[17] At the time of the Italian defeat at the battle of Caporetto in 1917.

[18] Letter from Huish to Romolo Bazzoni (Administrator of the Biennale), 12 February 1920. In a letter to *The Times*, Huish explained the reasons for the British Committee's refusal of the invitation to exhibit (19 March 1920). The Biennale recorded its side in a memorandum ('Promemoria', undated). All three are in Fondo Storico ASAC, Serie Scatole Nere Padiglioni: Gran Bretagna, busta n. 9, "XII Biennale 1920. Questione Inglese".

Huish (1843-1921) was Managing Director of the Fine Art Society. He had been made Chevalier of the Order of the Crown of Italy in 1910 in recognition of his services to the Biennale.

[19] Born in Budapest in 1872 and educated in Vienna, Konody had settled in London in 1889. He was the art critic for newspapers such as *The Observer* and *The Daily Mail* and the author of many books on art; he also served as artistic adviser to the Canadian War Memorials Fund (Rickards designed a building intended to house its paintings, never built). See the obituary in *The Times*, 2 December 1933, and the generous homage to him which appeared in the *Gazzetta di Venezia* on the first anniversary of his death ('Un benemerito delle Biennali: Paul George Konody', 30 November 1934, a copy of which is in Fondo Storico ASAC, Serie Scatole Nere Padiglioni: Gran Bretagna, busta n. 10). He too was created Chevalier of the Order of the Crown of Italy.

See also Nigel Richard Vaux Halliday, *Craftsmanship and communication: a study of 'The Times' art critics in the 1920s, Arthur Clutton-Brock and Charles Marriott*, Ph.D, Courtauld Institute of Art,

University of London, 1987, pp. 90-106 on Konody.

The Department of Overseas Trade came to look unfavourably on him (for their criticisms see BT 60 30/4).

[20] BT 60 30/4. The Department, created in 1918, had taken over responsibility for organising British participation in exhibitions overseas from the Board of Trade.

[21] Letter of 2 July 1921, BT 60 30/4. (Longden was then Director of the British Institute of Industrial Art.) A little later, however, he came out in favour of the Pavilion.

[22] Letter of 17 July 1921 (Fondo Storico ASAC, Serie Scatole Nere Padiglioni: Gran Bretagna, busta n. 9, "XIII Biennale 1922").

[23] "It has been offered to Spain for a considerably higher price" [than the £1,000 asked from the Government], wrote Konody to Longden (letter of 15 October 1921, BT 60 30/4). In the event Spain decided to build a new Pavilion, opened at the 1922 Biennale.

[24] Letter to Romolo Bazzoni, 3 November 1921 (Fondo Storico ASAC, Serie Scatole Nere Padiglioni: Gran Bretagna, busta n. 9, "XIII Biennale 1922").

[25] Confidential letter to Domenico Varagnolo, 15 April 1923 (Fondo Storico ASAC, Serie Scatole Nere Padiglioni: Gran Bretagna, busta n. 8). Among the artists whose works he added were Augustus John, Charles Ginner, Mark Gertler, Gerald Kelly, William Nicholson, John Nash and Sickert.

[26] The Faculty of Arts, founded in 1921, acted "for the Federation of the Arts and Art Societies and the enlistment of National interest in the creative Arts". It paid for the works to be sent to Venice, playing no part in the selection. (See *The Faculty of Arts Journal*, vol. 1, no. 2, April 1924, p. 21; no. 3, May-June 1924, p. 51; no. 5, April-May 1925, pp. 83 and 106; and on Leverhulme's involvement see Edward Morris in *Lord Leverhulme*, Royal Academy of Arts, London, 1980, p. 27.) Leverhulme died in 1925, and, although the Faculty was to have organised the 1926 British section, it did not in fact do so.

[27] 'Case of the British Pavilion. Needed Reforms. An Appeal to the Government', 27 April 1924. He argued that the existing Pavilion should be rebuilt: it is "mean and somber, in its decorations tawdry, and has the hall-mark of the jerry-builder."

[28] See BT 60 30/4, letter of 27 June 1924 to Sir William Clark (Comptroller General of the Department from 1917 to 1928). Clark also advised the Treasury against acceptance of the Pavilion in 1925.

[29] Neville Jason, *The Sculpture of Frank Dobson*, (Catalogue by Lisa Thompson-Pharoah), London, 1994, p. 70.

[30] In November Sir William Clark noted that the Department of Overseas Trade had resisted every suggestion that it take over the Pavilion "not only on the ground of economy but because we were not impressed with the personality of the managing committee." (Memorandum of 3 November 1927, BT 60 30/4.)

The new Secretary General of the Biennale, Antonio Maraini, came to London at this time to raise new interest in the Pavilion and encourage Government funding for it.

[31] Letter signed by Lord Montagu of Beaulieu, Lady (Maud) Cunard, Lord Ivor Spencer-Churchill, Sir Philip Sassoon, Charles Aitken and P. G. Konody.

[32] BT 60 30/4. The Confederation was designed to promote artistic interests by allied action between the various branches of the arts.

[33] The U. S. Pavilion opened in 1930, funded by Grand Central Art Galleries of New York: after 1932 when the British Government took over its Pavilion, the American alone was in private hands (and remains so today). See Philip Rylands and Enzo Di Martino, *Flying the Flag for Art. The United States and the Venice Biennale 1895-1991*, Richmond, Virginia, 1993, pp. 55-7.

[34] The deputation consisted of Prof. C. H. Reilly (President of the British Confederation of Arts), Sir Charles Holmes, Lord Henry Bentinck, Sir George Clausen, Frank Dobson, Prof. William Rothenstein and Prof. Henry Tonks.

[35] Internal memorandum of 24 March 1928 by L.A. de L. Meredith (BT 60 30/4). Another memorandum noted: "this would appear an opportunity for the Government at a very small sum to assist in

increasing the demand for British works of art at a time when artists ... are greatly in need of new markets." (22 March.)

[36] Confidential memorandum of c. April 1929, BT 60 30/4.

[37] This scheme for benefiting contemporary British artists through a series of special exhibitions was founded and financed by Duveen following his letter to Prime Minister Stanley Baldwin which drew attention to the lack of support for contemporary art in Britain (see *The Times*, 22 January 1926, p. 10; also British Artists' Exhibitions, *Report for 1927*).

[38] See the memorandum by Stocks of April 1929, and the draft minute by him of the same date, BT 60 30/4. Marsh (himself until Labour came to power in June, private secretary to the Chancellor of the Exchequer, Churchill) and Ede were on the Executive Committee of the CAS.

[39] Minutes of the meeting, Tate Gallery Archive. Lord Ivor Spencer-Churchill, Honorary Secretary of the CAS and a member of the British Committee at this time, stated that he had obtained for the CAS the option of taking over the administration of the British section.

[40] Letter to Austen Chamberlain, 7 August 1928, BT 60 30/4.

[41] An artist had represented Britain in the past.

[42] The Committee also handed over £621 invested in Tasmanian Government Stock.

[43] April 1932, BT 60 30/4. Maraini, Secretary General from 1928 to 1942, a sculptor and Fascist parliamentary deputy, was awarded a K.B.E. in 1938 in recognition for his efforts in promoting relations between Italy and Britain.

Only three works were, however, sold from the British Pavilion, a sculpture and a drawing by John Skeaping and a wood engraving by Eric Gill. 124 of the 241 exhibits were for sale. (See BT 60 30/4 and Fondo Storico ASAC, Serie Scatole Nere Padiglioni: Gran Bretagna, busta n. 10.) For a list of the number and value of sales made from 1909 to 1930 see Fondo Storico ASAC, Serie SN/P (Appendice), busta n. 1/8, "Padiglione della Gran Bretagna"; see also *La Biennale di Venezia. Storia e Statistiche*, Venice, c. 1932, p. 110.

[44] Tate Gallery Archive.

[45] Writing in confidence to Maraini in February 1936, Alfred Longden (Art Adviser to the Department) asked his advice on British participation at the coming Biennale in view of the tensions between the two countries: "Would the pictures be perfectly safe on the walls and would the public visit the pavilion?" Maraini replied: "The finishing schools for girls are open, and more are to start next month. If mothers – English and American – can trust their daughters to Italy, artists need not fear for their works." (Letter of 17 February 1936; both letters in Fondo Storico ASAC, Serie Scatole Nere Padiglioni: Gran Bretagna, busta n. 8.) See also busta n. 10.

[46] One painting – Paul Nash's *Cros de Cagnes* (1926/7), bought by the Italian Ministry of Education and now in the Galleria Nazionale d'Arte Moderna, Rome – and sixteen engravings and drawings by Stanley Anderson and Blair Hughes-Stanton were sold for a total of £163 (see BW 67/2 and BW 40/17, PRO, Kew).

The Committee was unanimously in favour of the construction of a new Pavilion on the site, the existing one being considered "thoroughly unsuitable from every point of view", too small, old-fashioned and lacking in "any architectural distinction", especially compared with the many new or newly rebuilt Pavilions in the grounds – notably the huge new Nazi German Pavilion of 1938 (Minutes of the eleventh meeting of the Fine Arts (General) Committee, 25 July 1938, BW 67/5, and report by Lord Balniel, June 1938, BW 40/17, PRO, Kew); but nothing came of this.

[47] WORK 10/403 (PRO, Kew).

[48] See BW 67/1-67/6, BW 78/1, BW 40/17 (PRO, Kew).

On the founding of the British Council in 1934 see Frances Donaldson, *The British Council. The First Fifty Years*, London, 1984, and Philip M. Taylor, *The Projection of Britain. British overseas publicity and propaganda 1919-1939*, Cambridge University Press, 1981.

[49] A painter by training, Major Longden had wide experience of organising international art exhibitions. He was Director of the Council's Visual Art Department between 1940 and 1947.

His aesthetic stance is suggested by his comment to Maraini when, during the packing up of works after the close of the 1932 Biennale, a hole was made in a painting by Matthew Smith: "... I can quite imagine someone getting annoyed with so stupid a picture." (Letter of 18 December 1932; Fondo Storico ASAC, Serie Scatole Nere Padiglioni: Gran Bretagna, busta n. 8.)

[50] See especially Janet Minihan, *The Nationalization of Culture. The Development of State Subsidies to the Arts in Great Britain*, London, 1977.

[51] Memorandum of 5 November 1929, BT 60 30/4.

[52] Many years later in 1960 a small service building was adapted for use as the Uruguay Pavilion.

[53] Reproduced in colour in the article by his assistant A.S. Covey, 'Frank Brangwyn's Scheme for the Decoration of the British Section at the Venice Exhibition', *The Studio*, London, vol. XXXIV, no. 146, May 1905, p. 284.

[54] Quoted in Covey's article, *The Studio*, May 1905, op. cit., p. 291. Cf. Rodney Brangwyn, *Brangwyn*, London, 1978, pp. 99-103.

[55] Listed in the Biennale catalogue as *I Fonditori, Gli Sterratori, I Vasai* and *I Fabbri*. The latter pair were placed at either end of the room, and the two larger ones, 165.1 x 541 cm, on the side walls. The titles by which the paintings are known in English vary slightly, for example *The Navvies*, or *Navvies at Work*, has also been called *Excavating* or *Excavators*, and *The Steelworkers* is also known as *The Rolling Mill*.

[56] See Archivio Storico ASAC, Serie Scatole Nere Padiglioni: Gran Bretagna, busta n. 9, "1905 Biennale. Mostra dell'Inghilterra".

[57] Illustrated in Covey, 'The Venice Exhibition', *The Studio*, vol. XXXV, no. 148, July 1905, p. 99.

[58] Letter of 29 November 1905 (Fondo Storico ASAC, Serie Scatole Nere Padiglioni: Gran Bretagna, busta n. 9, "1905 Biennale. Mostra dell'Inghilterra"). Prince Giovanelli also bought a painting by Brangwyn for the Galleria Internazionale d'Arte Moderna, Venice.

The gold medals which Brangwyn won in 1905 and again in 1907 are in the William Morris Gallery, Walthamstow (Brangwyn Bequest, 1956); in 1911 he was made Chevalier of the Order of the Crown of Italy, and in 1917 Commander of the Order of Saints Maurizio and Lazzaro.

[59] See A.S. Covey, 'The Brangwyn Room at the City Art Gallery, Leeds', *The Studio*, vol. XL, no. 169, April 1907, pp. 181-7; and Eric Cameron, 'Brangwyn and the Venice Murals in the Sam Wilson collection', *Leeds Arts Calendar*, no. 59, 1966, pp. 4-7 (I am grateful to Alex Robertson for this reference).

Wilson was a member of the British Committee in 1909 and 1910.

[60] Listed in the Biennale catalogue as *Scena Veneziana, Notte Veneziana, Agricoltori* and *Minatori*. See A.S. Covey, 'The Venice Exhibition: Mr. Brangwyn's Decorative Panels in the British Section', *The Studio*, vol. XLI, no. 171, June 1907, pp. 9-21; and Selwyn Brinton, 'The Seventh International Exhibition of Art at Venice, 1907', *The Studio*, vol. XLI, no. 174, September 1907, pp. 268-278.

The incongruous mixture was the result of the Venetian authorities' request for British subjects after Brangwyn had already completed the two Venetian murals.

[61] *The Studio*, September 1907, op. cit., p. 271.

[62] An account of the 1909 decoration, including the refitting of the carpentry in the central room, is given in Fondo Storico ASAC, Serie Scatole Nere Padiglioni: Gran Bretagna, busta n. 9, "Conti Padiglione Inglese dal 1909 al 1915".

The Pre-Raphaelites and their Followers at the International Exhibitions of Art in Venice 1895-1905

Sandra Berresford

 There can be little doubt that the British painters that Antonio Fradeletto, Secretary General of the Venice Biennale, and Italian art connoisseurs in general most wanted to see at the First International Exhibition in Venice in 1895 were the Pre-Raphaelites. These artists had received a far greater amount of coverage in the Italian press than any others in Europe, so much so that interest in Pre-Raphaelitism transcended the regional boundaries which traditionally dominated Italian art in the second half of the 19th century. Information on Pre-Raphaelitism arrived in two phases: firstly, in the 1880s, when discussion was largely literary; secondly, in the early 1890s, when it extended to the Fine Arts. First-hand knowledge of Pre-Raphaelite painting prior to the First Biennale remained, however, extremely limited: a few minor works had been shown at the Roman Exhibition Society *In Arte Libertas* in the years 1889 to 1893; others knew Pre-Raphaelite expatriates or made the effort to go to England to see their works.[1] Interest focused on Dante Gabriel Rossetti, not just because he best combined the role of poet and painter but because it was felt that he was intrinsically 'Italian'. Burne-Jones was seen as Rossetti's heir and Italian attention later centred on his life and work.

For an overview of contemporary British painting, Italians (and Fradeletto no less) relied very heavily on Ernest Chesneau's *La Peinture Anglaise,* published in Paris in 1884. Apart from those Pre-Raphaelites whose works did appear in the First Biennale (Millais, Hunt, Burne-Jones and Arthur Hughes), Chesneau discussed several other artists who were either to exhibit in Venice in 1895 or who were invited but did not exhibit (such as James Sant, Frank Holl, J.C.Hook and the Pre-Raphaelite landscapist, John Brett).[2] The second best-known source in Italy on Pre-Raphaelitism was Robert de la Sizeranne's 'La Peinture Anglaise Contemporaine', published in the *Revue des Deux Mondes* in October and November 1894. It is no coincidence that each of the artists selected for the First Exhibition stood, in de la Sizeranne's essay, for a particular strain of English art: Mythical (G. F. Watts), Christian (Holman

Hunt), Academic (Leighton), History (Alma-Tadema), Genre (Millais), Portraiture (Herkomer) and Legend (Burne-Jones).

So the Italians awaited the appearance of Pre-Raphaelite works in Venice with considerable anticipation, though with far from total acceptance: some were already intensely critical of the effects Pre-Raphaelitism had wielded on the eclectic Italian art produced over the previous decade; some suggested that Pre-Raphaelitism was well and truly dead.[3] One might wonder, then, whether Pre-Raphaelitism was over in Italy before a representative cross-section of their work had ever been seen. On the contrary, the Pre-Raphaelite works that *were* seen at the early Venice

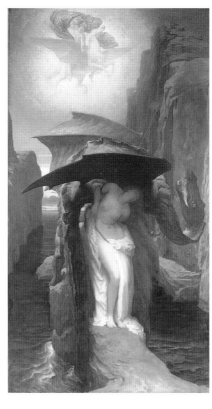

Frederic Leighton, *Perseus & Andromeda*, 1891, oil on canvas, 235 x 129.3 cm, Walker Art Gallery, Liverpool

Biennales (though far from representative and hardly a cross-section), together with the propagation of illustrated art magazines and the dissemination of reproductions not only of Pre-Raphaelite works but also of Arts and Crafts graphics and archetypes, ensured that it was to play a vital role in Italian art for yet another decade.

The Venice organisers could not, of course, quite apart from any logistical problems, have provided a representative collection of Pre-Raphaelite works because, initially, the exhibitions were limited to living artists and Ford Madox Brown and Dante Gabriel Rossetti were by then both dead. Fradeletto was himself a Pre-Raphaelite enthusiast (he lectured on Rossetti prior to January 1896)[4] and obviously had their work high on his list of *desiderata:* rather naively, he even had hopes of obtaining Hunt's famous *Light of the World* (1853, Keble College, Oxford) for the First Exhibition.[5] Unfortunately, he had no direct contacts in Britain at this time and had to rely very heavily on the selected Committee of Patronage, headed by the President of the Royal Academy, Frederic Leighton, who was joined by Lawrence Alma-Tadema, John Everett Millais and Edward Burne-Jones. This Committee produced a

dignified collection of pictures, representative of official taste, with no surprises.[6]

In the light of great Italian expectation, works by known Pre-Raphaelites at the First Exhibition were held to be very disappointing although they did draw the crowds. Millais, (no longer Pre-Raphaelite as the Italian press was at pains to point out), by now one of the most esteemed portrait and genre painters of the day, exhibited *The Ornithologist* (formerly *The Ruling Passion*, 1885, Glasgow Museums: Art Gallery and Museum, Kelvingrove, see illus. p. 53) and *The Last Rose of Summer* (1888, in the Collection of Sir Ralph Millais in 1967), a portrait of his daughter, Mary. The former was an important work, containing seven fine portrait heads, mostly of children for which Millais was famed, but there is a cloying sentimentality about the piece which alienates it from the sobriety of his Pre-Raphaelite period. Whilst recognising his amazing technical ability, particularly as a portraitist, there was a general sense of disillusionment amongst Italian critics, as if they had expected to see something else.[7] The public at large seem to have been most struck by its 150,000 Lire price-tag, a sum then unthinkable for any contemporary Italian painter. After Leighton's death, Millais replaced him as head of the English Committee of Patronage for the 1897 Exhibition and, in June 1896, only two months prior to his own death, he was invested by King Umberto I of Italy with the *Croce di Grande Ufficiale dell'Ordine dei Santi Maurizio e Lazzaro*.[8]

Like Millais, Holman Hunt was personally invited to exhibit in Venice by the then Mayor Riccardo Selvatico. Moreover, Fradeletto had charged his own emissary to London, the Roman painter Giulio Aristide Sartorio (1860-1932, whose articles on the Pre-Raphaelites, especially Rossetti, were to do much to dispel many inaccuracies in Italy about the Movement) to ensure Hunt's participation. After much assurance that the Royal Academy (to which he felt himself keenly opposed) would have no say in hanging his work, Hunt sent his *May Morning on Magdalen Tower* (1890, Lady Lever Art Gallery, Port Sunlight, see illus. p. 53).[9] Italian critics were, again, disappointed: they were ill-prepared for the harshness of colour and fineness of detail in so large a work although Chesneau had remarked on these aspects of Hunt's work. More significantly, the painting failed to express the 'Ideal of Christian art' which was, by now, automatically associated with Hunt's name.[10] Hunt was asked to exhibit in Venice again in 1900 but declined.[11]

Burne-Jones was also much courted by the Venice authorities.[12] He promised to send a 'special work' and 'some studies' in 1895 but, in fact, only

Edward Burne-Jones,
Sponsa de Libano,
1891, water-colour,
324 x 156 cm,
Walker Art Gallery,
Liverpool

sent the large water-colour *Sponsa de Libano* (1891, Walker Art Gallery, Liverpool) which was generally found unworthy of the artist's great international reputation.[15] Exhibition of his *Aurora* the following year in Florence and the many articles published on him in the contemporary Italian press kept Burne-Jones in the limelight. Yet, in spite of critical and public demand, he was never adequately represented at the Biennale. Attempts to organize a commemorative exhibition in Venice in 1899 were thwarted largely because works were already tied up at the New Gallery Commemorative Exhibition in London.[14] W. Graham Robertson lent the *Dream of Lancelot at the Chapel of the San Graal* (1896, Southampton Art Gallery) to Venice in 1901 and may also have lent the six drawings exhibited that year. Though appreciation was expressed of the drawings, it was felt that the Biennale had failed to do justice to a great artist.[15]

To return, however, to the First Exhibition, two rather minor painters were left to champion the Pre-Raphaelite cause: Arthur Hughes (1832-1915) and his nephew, Edward Robert Hughes (1851-1914). The former exhibited a 'coolly elegant' triptych, *Viola d'Amore* (untraced); the latter sent two water-colours: *Biancabella and her Snake Sister (Samaritana)* (untraced, inspired by an episode from Straparola's *Piacevoli Notti*) and another (taking its title from a poem by Christina Rossetti: *"Oh, what's that in the hollow, so pale I quake to follow? / Oh, that's a thin dead body which waits the eternal term"*, Trustees of the Royal Society of Painters in Watercolours, London), depicting an Ophelia-like creature, trapped amidst briar roses.[16] All three works were reproduced in the official catalogue. The success of E. R. Hughes's works can be attributed, in part, to their dependence on 'suitable' literary sources. Though exhibiting in 1897 (A. Hughes, The *Door of Mercy*) and 1899 (E. R. Hughes, *The Fugitives*, from Masuccio Salernitano's *Novellino)*, the critical success of 1895 was not repeated.

William Michael Rossetti, (chosen for his knowledge of Italian no less than for his prestigious name), chaired the International Prize Jury at the First Exhibition which had a certain Pre-Raphaelite bias: alongside critics Julius Lange and Richard Muther, it included Adolfo Venturi and the aforementioned Robert de la Sizeranne. Although the Jury provided no sensational results, it may well have been due to W. M. Rossetti that Whistler's *Symphony in White, No.2: The Little White Girl* (1864, Tate Gallery, London) was awarded the 2,500 Lire of the *Premio Internazionale del Comune di Murano,* reserved for works previously exhibited outside Italy. Rossetti had, after all, spoken up for

Whistler at the Ruskin trial and this painting (intentionally or not) is the closest Whistler ever came to subject painting in the Victorian tradition. Fradeletto later persuaded W. M. Rossetti to send a paper to the International Congress in Venice in 1905; he had less success in convincing him to lend works by his brother to the Biennale of 1897.[17] A further attempt in 1900 also failed.[18]

As time progressed and the network of contacts grew, the organization of the Venice Exhibitions became more sophisticated and less dependent on the Establishment- bound British Committees. 1897 saw the works of three newcomers to Venice who were destined to make their mark there for several years to come: Walter Crane, Frank Brangwyn and the sculptor George Frampton.[19] Crane's two allegories, *Symbols of Spring* and *Freedom!* (untraced) received mixed reviews. Brangwyn, who turned Morris's decorative influence into a style uniquely his own, fared better with his four works, one of which, *St. Simon Stylites,* was purchased for the newly created International Gallery of Modern Art in Venice (Ca' Pesaro). Frampton's three works: the bas-reliefs *Santa Cristina* (1889, Walker Art Gallery, Liverpool), *My Thoughts are My Children* and *Mother and Child* (reproduced in *The Studio* in January 1896) were all fine examples of late Pre-Raphaelite sculpture. Frampton's *Belle Dame Sans Merci* was purchased for the International Gallery of Modern Art in Venice from the 1909 Exhibition.

The presence of these three artists, plus that of the Glasgow School in 1897 and C. R. Mackintosh *et al* in 1899, is a clear indication that Fradeletto and his team were now relying heavily on *The Studio* to fill in the many lacunae in their knowledge of contemporary British art. Analysis shows that many of the works shown in the early Venice exhibitions were discussed or even illustrated first in *The Studio*. Moreover, the British magazine was a fundamental influence on the leading art periodical in Italy at the time, *Emporium* (founded January 1895) which, itself, closely documented the careers of British artists who were featured in the early Biennales.[20] Although *The Studio*

James McNeill Whistler, *Symphony in White. No.2: The Little White Girl,* 1864, oil on canvas, 76.5 x 51.1 cm, Tate Gallery, London

gave an (Arts and Crafts) biased view of what was going on in the British art world at the turn of the century, a discerning reader could have divined more radical trends in exhibition reviews (of the International Society of Sculptors, Painters and Gravers, the New English Art Club and the Newlyn Exhibitions, amongst others).

Convinced that the former method of inviting artists to the Venice Exhibitions by consulting 'old memories and old catalogues' was 'totally unsatisfactory', Fradeletto began to travel to see exhibitions first-hand in Paris, Munich (where he appreciated the Glasgow School) and, in June 1898, London.[21] He also appointed a 'Representative in London' for the Biennale: a role filled, as of September 1898, by the journalist and theatre critic Mario Borsa (1870-1952).[22] Diligent and enthusiastic, Borsa appears to have had little pictorial instinct and still less inclination for the avant-garde; his tastes seem to have coincided with those British artists with whom he worked most closely on organising the exhibitions: Crane, Brangwyn, John Lavery – and the landscapist Alfred East. One of his first tasks was to persuade Crane to decorate the British Room at the Third Biennale but, although he initially agreed, Crane proved too busy to do this.[23] In 1899 he sent two works to Venice, the *Swan Maidens* (1894, untraced) and the imposing social allegory *The World's Conquerors* (Coll. Luigi Squarzina, Milan) which, like all the works he exhibited there, received mixed reviews.[24]

While it is not possible here to examine Borsa's activities in London in any great detail, it may be of interest in this context to know that, in 1899, his efforts were concentrated not only on Crane and Burne-Jones (see above) but also on getting Charles Ricketts to exhibit (though he was only to do so in 1912), and in dogged attempts to get something from the old and ailing G. F. Watts (still held in high repute in Europe) and from Alma-Tadema.[25] He proposed an exhibition of British graphic art (much esteemed in Italy) which was, apparently, sacrificed in favour of a Whistler exhibition which, in turn, failed to materialize (only three, or possibly five, works by Whistler were shown in Venice in 1899).[26] At the Grafton Gallery (where he enjoyed Charles Conder), the New Gallery (where he may have signalled *Evensong* by Burne-Jones's disciple, J. M. Strudwick, 1849-1937, who was unable to exhibit it in Venice)[27] and the New English Art Club (where works by avant-garde artists such as Will Rothenstein, Walter Sickert and Wilson Steer *were* on show) there was, apparently, '...nothing or very little that's really good'.[28]

Brangwyn, who accompanied Borsa to the Grafton Exhibition, sent three

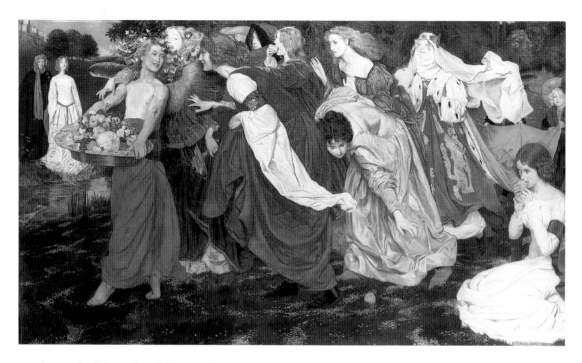

works to the Biennale of 1899 and got a mixed reception. The works of two little-known artists were generally preferred: Harry Robert Mileham's *Joseph Sold to the Israelites* (untraced) and Gerald Moira's (1867-1896) *Love's Orisons: Never Knight More Brave, Never Maid More True* (Sotheby's Belgravia, 24.10.1978 as *'Cavalier')*, since both were considered to have 'moved on' from the harshness and painful accuracy of Pre-Raphaelite draughtsmanship, though owing their composition and colourful palettes to that tradition.[29] The latter, particularly, lent itself to a lengthy literary description and, since the majority of Italian critics came from literary backgrounds, they found it easier to discuss such works than to come to terms with the painterly qualities of an artist like Whistler.

In May 1899, Borsa promised Fradeletto something better for the forthcoming Fourth Exhibition and proposed a small section of decorative art (the 'school of Morris, Ruskin, Crane').[30] Interest in Ruskin surged in Italy after his death in 1900. Though attempts were made to secure a collection of drawings by Ruskin (and, again, by Rossetti), nothing came of this. Venice was to celebrate the writer who had done so much to glorify Her by a rather meagre exhibition of his publications, organized by the publisher Ongania and by Robert de la Sizeranne's commemoration at the Venice International Congress, both in 1905.

In fact, the British section in 1901 was overshadowed by the novelty of works from the U.S.A. and by Americans Resident in Paris (organised through the good offices of John Singer Sargent, whose family connections with Venice are well-known). Two of the most successful British works were by the late Pre-Raphaelite and *Studio* protégé Byam Shaw (1872-1919): *Love's Baubles* (1897, appositely illustrating a poem from D. G. Rossetti's *House of Life* and lent by the Walker Art Gallery, Liverpool which had purchased it in 1897) and *Whither?* (1895, exhibited at the R.A. in 1896, untraced).[31] These were exactly the kind of decorative, colourful, literary works with which Italian critics could deal; moreover they coincided with a revival of interest in Italy in the life and works of D. G. Rossetti which included the first authoritative translation of his *Poems*.[32] W. Graham Robertson's *Silver Mirror*, at the same exhibition, was also described as 'Rossettian' in the catalogue.

The Fifth Biennale saw the creation of a room dedicated to portraiture where Britain and the U.S.A. figured strongly, though Borsa's attempts to secure a work by G. F. Watts, (his *Portrait of Walter Crane),* and another by Madox Brown *(Portrait of C. A. Swinburne),* were unsuccessful.[33] The Fifth and Sixth Biennales (1903, 1905) were dominated by large allegorical works by Byam Shaw and Crane (now considered rather old hat) and by decorative works by Brangwyn. Brangwyn enjoyed great official and commercial success in Venice; he decorated the British rooms and helped to organize the British contribution on several occasions.

There were a few new presences in these years that can be classified as belonging to a Pre-Raphaelite tendency: amongst these, in 1903, were J. R. Clayton and R. Anning Bell's *The Three Maries,* (cartoons for the Chapel of Wellington Barracks, executed in mosaic by the Venice and Murano Company); the latter's *Cup of Water* was well received the following year; F. Cayley Robinson's *By the Light of the Hearth* and Maxwell Armfield's *Indifference* (both in 1905). Indubitably, the most important Pre-Raphaelite piece on show in 1905 was *The Lady of Shalott* by J. W. Waterhouse (1849-1917), a work of 1894, lent by Leeds City and now in their City Art Gallery (see illus. p. 63). A large, magnificent but eclectic fusion of Rossetti and Burne-Jones, it failed to cause the stir which it would almost certainly have provoked had it been exhibited earlier.

By 1903, the new stars of portraiture and landscape were dominating the Biennales, two genres in which the British School was always held to excel: John Lavery and John Singer Sargent dominated the former, Alfred East and

the Glasgow Boys the latter. Some elements of Anglo-American modernism had finally managed to creep into the Biennales by 1905: in broad terms, through Whistler, Lavery and Sargent, through the Naturalism of Stanhope Forbes (1899, 1905), James Guthrie (1897), Harrington Mann (1897, 1899, 1903), H. H. La Thangue (1903, 1905), George Henry (1903) and George Clausen (1901, 1905), all of whom were open, in varying degrees, to Impressionism. There were, indeed, even more radical works (or works presumed such) from Britain: Walter Sickert (1903), Walter Bayes (1905), and William Nicholson (1905); from Canada: James Morrice (1903, 1905) and from the United States: Frederick Childe Hassam (1901), Frederick Frieseke (1905), Richard Miller (1905) and Eugene Vail (1901, 1903, 1905). Since French Impressionism and Post-Impressionist painting was just beginning to be appraised – not always favourably – in Italy at the turn of the century, it is not surprising that the above-listed artists failed to win the appreciation either of the Italian critics (with the exception of a very few, like Vittorio Pica) or of the public at large, for many years to come.[34]

NOTES

Note: The author undertook research into British and American artists at the Venice Biennales (1895 to 1914) in the ASAC *(Archivio Storico delle Arti Contemporanee)* in 1986 as a contributor to a project undertaken by the Scuola Normale Superiore in Pisa to identify the works exhibited in Venice over the said period. Results are due to be published this forthcoming Summer.

Documents in the ASAC, concerning the Pre-War organisation of the Biennales, consist of some 40 *Scatole Nere* (SN – literally 'Black Boxes', full of correspondence from and to artists and documents relating to administrative and organisational matters), the *Collezione Autografi* (CA – a rather random selection of autograph letters), Sales Registers and Copy Books. Numbers, where recorded, refer to Fradeletto's own system. The photographic Archive is far from complete and the identification of many works is problematic.

[1] I have dealt elsewhere at greater length with the ways in which Pre-Raphaelitism filtered through to Italy: 'Giovanni Costa ed i suoi rapporti artistici con l'Inghilterra' in *Nino Costa ed i suoi amici inglesi*, (ed. P. Nicholls), Circolo della Stampa, Milan 1982 and 'Preraffaellismo ed estetismo a Firenze negli ultimi decenni del XIX secolo' in *L'Idea di Firenze. Temi ed Interpretazioni nell'arte straniero dell'Ottocento. Atti del Convegno*, Florence, December 1986, Centro Di, Florence, 1989.

[2] ASAC SN1 *Adesioni pervenute da artisti stranieri all'invito di partecipare all'Esposizione di Venezia*. John Brett did promise a work in 1895 but had had to abandon it and start again because the weather had been too dark (SN5 J. Brett to the Exhibition Secretary, 29th Jan. 1895). Though invited again in 1897, Brett never exhibited in Venice. Other artists who did appear at the First Biennale had also been discussed by Chesneau: Henry W. B. Davis, Herkomer, Leighton, Briton Rivière and G. F. Watts. Davis (1833-1914) had been influenced by Holman Hunt and, like Brett, is considered a leading Pre-Raphaelite landscapist although his style broadened in later years. His luminous *An Orchard in Picardy* of 1892 (Sale: Sotheby's New York, 28.10.1986 No. 131) was exhibited with *The Shadow of Evening* in Venice in 1895 but Italian critics failed to relate it to Pre-Raphaelitism.

[3] See, for example, A. Stella, 'Il Socialismo nell'Arte' in *La Tribuna*, Nov.1894 pp.352-355 and G.A. Sartorio, 'Ancora dei Preraffaelliti' in *La Nuova Rassegna, 17* April 1894; in response to the Biennale itself, see E. Thovez, 'Il Nuovo Rachitismo' (1895) republished in *Il Vangelo della Pittura ed Altre Prose d'Arte*, Turin & Genoa, 1921 pp.119-127 and V. Pica, *L'Arte Europea a Venezia*, Naples 1895 pp. 19-38, both of whom warned of the dangers of implanting the essentially British Pre-Raphaelitism on Latin culture and temperament. Sartorio's fundamental articles on Rossetti (*Il Convito*, Book II, 1895, pp. 121-150 and Book IV, pp.261-286) also substantially mark his conviction that it was time to move on from Pre-Raphaelitism to a new anthropomorphic 'National Art', rooted in the Renaissance.

[4] R. Barbiera, 'Dante Gabriele Rossetti, Sue Lettere e Memorie' in *L'Illustrazione Italiana*, 7.2.1896 says that Fradeletto lectured on Rossetti in Milan and elsewhere.

[5] SN 1 *L'Esposizione Veneziana a Londra (*A press release, in Fradeletto's hand) refers to 'La Luce nel Mondo – che forse vedremo a Venezia'.

[6] The British Section at the *Exposition Universelle* in Paris in 1889, together with the aforesaid list of *desiderata*, form a corpus very similar to British Rooms at the First and Second Biennalès. Fradeletto and his team were to monitor closely the annual *Jahresausstellung* and the Summer *Secessions* in Munich as the presence of the Glasgow Boys (from 1897) and Mackintosh *et al* (in 1899) at the Venice Biennales, shortly after successes in Munich, demonstrates.

[7] V. Pica, Op.cit. pp.39-43.

[8] Cfr. correspondence in the ASAC: Lady Effie Millais 21 Feb. '94 to the Mayor of Venice (CA); Id., 22nd Jan.1895 (SN5, No.288/b); Id., Feb.21st (1895) No.593; Id., 5 March 1895 (SN5, No.731); Press releases No.30 (stamped 28 Feb '96) (SN7) and No.15 (Stamped 5 June '96) on honours (SN7).

[9] Cfr. correspondence in the ASAC: H.H. to the Mayor of Venice, Aug. 17 1894 (C.A. No. 820/b); H.H. (Secretary) Jan. 25 1895 (SN5, No.1079); H.H. to the Mayor of Venice, March 9 1895 (CA); Tickets of Notification (SN5, referring to the Birmingham City Art Gallery tondo of *May Morning);* G.Holman Hunt, (SN5, No.1045); H.H. March 22 1895 (SN5, No.1079). My thanks to Judith Bronkhurst for pointing out a letter from H.H. to G. A. Sartorio with regard to the former's participation at the First Biennale (dated August 28 1894, Archives of the History of Art. The Getty Center for the History of Art and the Humanities, Los Angeles, California, No. 860667).

[10] V. Pica, Op.Cit. pp. 28-30; E. Panzacchi, 'L'Esposizione Artistica a Venezia' in *La Nuova Antologia*, 1 August 1895, p.399.

[11] (For) H.H., July 31st (1900) (SN12 No.66/18).

[12] Cfr. correspondence in the ASAC: Riccardo Selvatico to EBJ, 1 Feb 1895 (SN5 Nos. 9?64-9?65); EBJ, Feb. 18 1895 (CA No.547); Philip Burne-Jones to A. Fradeletto, Aug. 14 1895 (CA No.1813); Comitato di Patrocinio, Feb. 1896 (SN7); EBJ telegram, l8.4.96 (SN7). Earl of Wharncliffe to F. Grimani, Mayor of Venice (CA stamped 4 Sep. '98 – refusing to lend).

[13] E. Panzacchi, Op.cit. pp.398-399; V. Pica, *L'Arte Mondiale a Venezia*, Naples 1897 (p.39, lamenting the absence of Hunt and Burne-Jones at the Second Exhibition).

[14] M. Borsa to Antonio Fradeletto, 16 Jan 1899; Id., 9 Feb.1899; Id., (stamped) 14.3.'99; Id., 4 Apr. '99 (SN 9) on various attempts to borrow works by Burne-Jones.

[15] S. D. Paoletti, *L'Arte alla IV Esposizione Internazionale di Venezia*, Trento 1901 p.92.

[16] E. Panzacchi, Op.cit. p.399; V. Pica, Op.cit. 1895 pp.34-35; A. Melani, 'Miscellanea, Prima Esposizione d'Arte della Citta di Venezia' in *Emporium*, June 1895 p.486.

[17] Although there is no evidence in the ASAC to document an attempt to produce a Rossetti exhibition for 1897, the critic Vittorio Pica (normally well-informed and close to Fradeletto), told his readers that the Rossetti family had sent some drawings by D. G. Rossetti at the last minute but that these had been rejected by the Committee because they would have revealed his 'quite frequent errors in draughtsmanship and technical deficiencies' rather than 'the delicate poetry of his mystical visions', V. Pica, 1897 Op.cit. p.39.

[18] W. G. Collingwood (Ruskin's former Secretary) to Antonio Fradeletto, Oct. 30 1900 (SN12 No. 1?78/1) in which he advises A.F. to ask Mr.and Mrs. Arthur Severn about the loan of Ruskin material;

'As to work by Rossetti, I really do not know how many pictures could be got, nor where they are. Mr. Ruskin had only one'.

[19] For a description of Crane's works, see: V. Pica, Op.cit. 1897 pp.40-41. A line drawing of *Freedom* probably circulated for the Socialist cause (Witt Library); the painting was sold to a collector in St Petersburg for 5,000 Lire.

[20] C. Ashwin, '*The Studio* was not conspicuously radical in outlook, ignoring many of the foremost art trends of the 1890s' in *High Art and Low Life: The Studio and the Fin de Siècle*, Special Centenary Number of *The Studio*, Washington,1993 p.5. It is a pity that *The Studio's* influence in Italy was entirely overlooked on this occasion. *Emporium's* well-illustrated series of articles on *Artisti Contemporanei* included Leighton, G. F. Watts, Burne-Jones, Frampton, D. G. Rossetti, Millais, Alma-Tadema, Madox Brown, Herkomer, Ruskin, Crane, Brangwyn and Poynter between 1895 and 1900.

[21] A. Fradeletto to his assistant in Venice, Romolo Bazzoni, dated London 5.VI.'98 (SN9 No.23). He noted that they had seen some seven or eight thousand pictures in a few days, many by artists of whom he had never even heard. Fradeletto had visited Munich towards the close of 1896 (AF to R. Selvatico, 10 Nov. '96 SN7) and Paris on at least two occasions.

[22] SN9 A. Fradeletto to Dicksee, October '98 with Borsa's credentials to act as Biennale agent in London. Borsa filled this role until around 1910; he was assisted on several occasions after 1905 by Fradeletto's son, Giulio.

[23] A. Fradeletto to Walter Crane, 12 Oct. 1898 (SN9): Crane's decorations of Room V were to be 'of simple and characteristic elegance'; it was an opportunity 'to further relations between England and Italy in the decorative arts'. Mario Borsa to A. Fradeletto 16 Jan.1899 reported Crane too busy to fulfil his commission (SN9).

[24] U. Fleres, *Esposizione Artistica Internazionale di Venezia*, Rome 1899, p.87; M.Morasso, 'L'Arte Mondiale alla III Esposizione di Venezia', in *La Nuova Antologia*, 1 Nov. 1899 p. 152; V. Pica, *L'Arte Mondiale a Venezia*, 1899 p.36. Crane fared better at the Exhibition of Decorative Art in Turin in 1902.

[25] M. Borsa to A. Fradeletto, 7 Nov. (1898) (SN 9); Idem., stamped 10 Nov. '98 (SN9); Id., 11 Nov. (1898) (SN9); Id., 19 Nov. (1898) (SN9); Id., 30 Nov. (1898) (SN9); Id., 27 Dec. '98 (SN9); Id., 16 Jan. 1899 (SN9); Id., 9 Mar.1899 (SN9); Id., postmarked 14 Mar. 1899 (SN9).

[26] Vittorio Pica wrote to Fradeletto, 26.XI.1900 (SN12 No.5?27/1) that he had been right to sacrifice the *Mostra Bianco e Nero* in homage to Whistler. Three works were shown: *Rose and Silver: La Princesse du Pays de la Porcelaine* (YMSM 50*); Crepuscule in Flesh Colour and Green: Valparaiso* (YMSM 73) and *The Thames in Ice* (YMSM 36); *Harmony in Grey and Green: Miss Cecily Alexander* (YMSM 129) and *At The Piano* (YMSM 24) were listed with the latter in the official catalogue as 'due to arrive' (where YMSM = M. MacDonald, A. M. Young, R. Spencer with the assistance of Hamish Miles, *The Paintings of James McNeill Whistler*, New Haven and London, 1980). According to Pica (Op.cit. 1899), the *Thames in Ice* had arrived by mid-July but the last two paintings had not. W.C. Alexander wrote to Filippo Grimani (Mayor of Venice) on June 12th 1899 declining to lend the portrait of his daughter (it had been in Dublin on exhibition until the end of May) (SN 9 No.406). J. J. Cowan wrote from Florence that he could not lend either *The Piano* or *The Thames in Ice* because they were promised for an exhibition in Edinburgh (73rd Royal Society of Scottish Artists) (SN 11 Notes in Fradeletto's hand, Biennale stamp 18 Mar '99); Fradeletto telegrammed to insist at least for *The Piano*. It seems curious that *The Thames* should have arrived and not *The Piano*, since they both belonged to Cowan; most reviews were written by July 1899 and I have not yet found any evidence to corroborate whether *Miss Alexander* and *The Piano* were actually shown in Venice.

[27] Strudwick provided the name and address of the owner but the work was not shown (SN8 July 4th 1898).

[28] M. Borsa to A. Fradeletto, 19 Nov. (1898) (SN9).

[29] U. Fleres, Op.cit. p.89; M.Morasso, Op.cit. p.153.

[30] M. Borsa to A. Fradeletto, (SN9 No. 3096 Biennale stamped 31 May '99).

[31] S. D. Paoletti, *L'Arte alla IVa Esposizione Internazionale di Venezia*, (extract from *L'Alto Adige*), Trento, 1901 pp. 91-93.

[32] Antonio Agresti, *Poesie di Dante Gabriel Rossetti. Traduzione dall'inglese ...con uno Studio su la Pittura Inglese e l'Opera Pittorica e la Vita dell'Autore*, Florence, G. Barbera, 1899.

[33] M. Borsa to A. Fradeletto, 23 Jan. (1903) (SN 20) and 24 March 1903 (SN 20).

[34] I touched on the reception of Impressionist and Post-Impressionist painting in Italy in *Post-Impressionism. Cross-Currents in European Painting*, Royal Academy of Arts, London 1979-1980, pp.218-226.

Chronology

British artists exhibited at the
Venice Biennale 1895-1995

including the names of British commissioners, committee and jury members
and prize winners

NOTES

Artists shown in the English or Scottish rooms or, from 1909, in the British Pavilion are
listed first, followed by British artists included in other Biennale displays.

* An asterisk denotes an artist born abroad but living in Britain (at the time of the exhibition).

** Two asterisks denote an artist born in Britain but living abroad. They are used on the
first occasion an artist exhibits only. A 'British' artist is thus defined broadly, rather than
strictly by nationality.

Different editions of the Biennale catalogue can vary slightly.

The word 'Biennale' was used in the title only from 1930; until that date the exhibition
was the Esposizione Internazionale d'Arte della Città di Venezia.

Britain did not participate in the Biennales of 1920, 1936, 1940 and 1942.

The Biennales have not always been held every two years: only one year elapsed
between the 8th (1909) and the 9th (1910); the exhibitions that might have been
expected in 1916, 1918, 1944 and 1946 were not held due to the two world wars; the
traditional Biennale was suspended in 1974; there was a three-year gap between the
44th (1990) and the 45th (1993) exhibitions.

1 1895

International Committee of Patronage included Lawrence Alma-Tadema, Sir Edward Burne-Jones, Sir Frederic Leighton and Sir John Everett Millais from England.

Whistler's *Symphony in White, No. 2: The Little White Girl* won the Premio Internazionale del Comune di Murano.

(All the artists listed here, including Whistler, were exhibited together in the same room, Sala A.)

Lawrence Alma-Tadema*
Sir Edward Burne-Jones
John Collier
Henry W. B. Davis
Alfred East
S. Melton Fisher
Hubert von Herkomer*
Arthur Hughes
Edward Robert Hughes
William Hulton**
William Holman Hunt
Sir Frederic Leighton
William Logsdail**
Sir John Everett Millais
Clara Montalba**
Walter William Ouless
Alfred Parsons
William Blake Richmond
Briton Rivière
George Frederick Watts
James Abbott McNeill
 Whistler*

(1895) John Everett Millais, *The Ornithologist*, (formerly *The Ruling Passion*), 1885, oil on canvas, 160.7 x 215.9 cm, Glasgow Museums: Art Gallery & Museum, Kelvingrove

William Holman Hunt, *May Morning on Magdalen Tower*, 1890, oil on canvas, 157.5 x 204.5 cm, Lady Lever Art Gallery, Port Sunlight

1897

International Committee of Patronage included Lawrence Alma-Tadema, Sir Edward Burne-Jones, Hubert von Herkomer, Sir John Everett Millais [died 1896] and William Quiller Orchardson from England.

England

Lawrence Alma-Tadema
Frank Brangwyn
John Collier
Walter Crane
Henry W. B. Davis
Alfred East
S. Melton Fisher
Robert Fowler
George Charles Haité
Arthur Hughes
William Hulton
Frederick William Jackson
George Percy Jacomb-
 Hood
Moffat Lindner
William Logsdail
Clara Montalba
Adrian Stokes
William Stott of Oldham
Henry Scott Tuke

Scotland

Robert Brough
Alexander K. Brown
Thomas Austen Brown
D. Y. Cameron
R. McG. Coventry
John P. Downie
Alexander Frew
David Fulton
James Guthrie
James Whitelaw Hamilton
Mason Hunter
Archibald Kay

J. Kerr-Lawson
John Lavery
Walter McAdam
William MacBride
Bessie MacNicol
Harrington Mann
Thomas Corsan Morton
John Reid Murray
Francis H. Newbery
Patrick W. Orr
James Paterson
William Pratt
Wellwood Rattray
Tom Robertson
Crawford Shaw
Harry Spence
R. Macaulay Stevenson
John Terris
Grosvenor Thomas
Constance Walton
Edward Arthur Walton

International rooms

George Frampton

(1897) John Lavery, *Portrait of R. B. Cunninghame Graham,* 1893, oil on canvas, 203.2 x 108.2 cm, Glasgow Museums: Art Gallery & Museum, Kelvingrove

International Committee of Patronage included Lawrence Alma-Tadema, Walter Crane, Hubert von Herkomer, William Quiller Orchardson and Sir Edward John Poynter from England.

Jury included John Lavery.

No prizes were awarded this year; instead works by artists including John Lavery and George Smith were purchased for the Galleria Internazionale d'Arte Moderna in Venice.

England

Lawrence Alma-Tadema
Edgar Barclay
Frank Bramley
Frank Brangwyn
Walter Crane
Constance Dale
Alfred East
C. Maud Ede
Arthur Englefield
S. Melton Fisher
I. L. Gloag
Maurice Greiffenhagen
George Charles Haité
Dudley Hardy
Hubert von Herkomer
Rowland H. Hill

Edward Robert Hughes
William Hulton
George Percy Jacomb-Hood
Moffat Lindner
L. C. Macrae
Harry Robert Mileham
Gerald Moira
Clara Montalba
Hilda Montalba**
Sir Edward John Poynter
Bertram Priestman
Flora M. Reid
Sir William Blake Richmond
George Sauter*1

James Jebusa Shannon*2
Harry G. Shields
Charles Edward Stewart
Elisabeth R. Taylor*
Harry Thompson
George Frederick Watts

Lawrence Alma-Tadema, *An Egyptian Widow in the Time of Diocletian*, 1872, oil on panel, 74.9 x 99.1 cm, Rijksmuseum, Amsterdam

1 Bavarian-born Sauter was shown as German in 1897, 1901 and 1903, but in 1907 appeared again in the English room.
2 Shannon was shown as American in 1905 and 1907, but exhibited in the British Pavilion in 1914.

(1899) Jessie M. King, *Pelléas and Mélisande, c.*1899, pen and ink on vellum, 30.5 x 13.3 cm, courtesy The Fine Art Society, London

Scotland

Alexander K. Brown

Thomas Austen Brown

R. McG. Coventry

John P. Downie

David Fulton

J. Hermiston Haig

James Whitelaw Hamilton

Peter Alexander Hay

Mason Hunter

Archibald Kay

John Lavery

Walter McAdam

Harrington Mann

William Milne

Francis Henry Newbery

Patrick W. Orr

James Paterson

William Pratt

Wellwood Rattray

Tom Robertson

Alexander Roche

George Smith

Harry Spence

R. Macaulay Stevenson

John Terris

Constance Walton

Edward Arthur Walton

Scottish Decorative Art

John Guthrie

Jessie M. King

Frances E. Macdonald

Margaret Macdonald

Charles Rennie
 Mackintosh

J. Herbert McNair

Jessie R. Newbery

International rooms

E. A. Abbey*

Thomas Austen Brown

Stanhope Alexander Forbes

Andrea Carlo Lucchesi

David McGill

Solomon J. Solomon

(1899) Jessie M. King, *Pelléas and Mélisande, c.*1899, pen and ink on vellum, 30.5 x 13.3 cm, courtesy The Fine Art Society, London

1901

Purchases for the Galleria Internazionale d'Arte Moderna, Venice, included Alfred East and E. A. Walton.

England

Robert W. Allan
George Henry Boughton[3]
Frank Brangwyn
Edward Burne-Jones
George Clausen
Alfred East
S. Melton Fisher
William Hulton
Clara Montalba
Hilda Montalba
A. D. Peppercorn
Briton Rivière
W. Graham Robertson
Byam Shaw
José Weiss

Scotland

Robert Burns
James Whitelaw Hamilton
Archibald Kay
John Lavery
Charles H. Mackie
J. Campbell Mitchell
James Paterson
Robert Cowan Robertson
George Smith
John Terris
William Walls
Edward Arthur Walton

International rooms

(Paintings)
Walter Crane
Alfred East
John Lavery
William Quiller
 Orchardson

(Bianco e Nero)
[Black and White section:
works on paper]
Edward Burne-Jones
J. M. Swan

Exhibition of medals and plaquettes

George Frampton

Opposite: William Quiller Orchardson, *Portrait of Sir David Stewart*, 1896, oil on canvas, 218.7 x 168.4 cm, City of Aberdeen Art Gallery & Museums Collections

[3] Showed in the American room in 1899.

5 1903

Gold medals introduced this year, and continued until 1907 (the medal was designed by Katie Joyce Harris of London – see opposite); one was won by John Lavery.

International rooms

Frank Brangwyn
Alexander K. Brown
J. R. Clayton and Robert Anning Bell
Robert McG. Coventry
Walter Crane
Eugene Dekkert
Alexander Brownlie Docharty
Alfred East
C. Maud Ede
S. Melton Fisher
George Frampton
Charles Wellington Furse
James Whitelaw Hamilton
Dudley Hardy
John Henderson
Joseph Morris Henderson
Archibald Kay
Henry Herbert La Thangue
John Lavery
Harrington Mann
Francis H. Newbery
Byam Shaw
Walter Sickert
George Smith
Solomon J. Solomon
John Terris
Edward Arthur Walton

Sala del Ritratto Moderno

[Modern Portraits]

Robert Brough
Arthur Stockdale Cope
Arthur Hacker
George Henry
Hubert von Herkomer[4]
John Lavery
William Mouat Loudan
William Richmond
Edward Arthur Walton
J. A. McNeill Whistler[5]

[4] Listed here as German.
[5] Whistler was listed this year as English, and he had shown in 1895 in the room of British artists, but on the other occasions he exhibited (1897, 1899, and posthumously in 1905, 1909 and 1934) he was listed as American.

Gold Medal of 1903 designed by Katie Joyce Harris of London.
Harris entered the international competition to design the medal, which was to bear an allegorical representation of Venice, recalling her artistic glories. She made two maquettes; a modified version of the one illustrated here (recto and verso) was used for the actual medal.[A] John Lavery won one in 1903. Medals were also awarded at the two subsequent Biennales (Brangwyn won one in 1905, and again in 1907 as did John Singer Sargent).

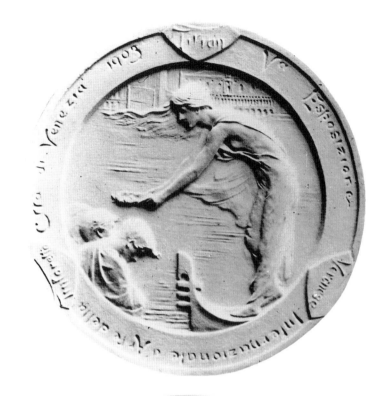

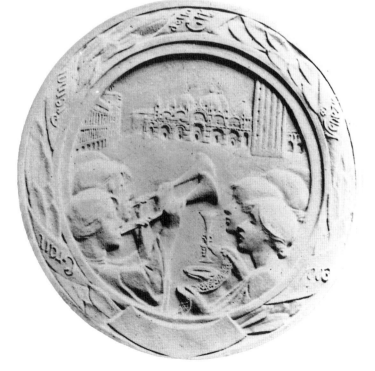

[A] See Fondo Storico ASAC, Serie Scatole Nere, busta n. 16, Concorso Medaglie, "Rose". The completed model is illustrated in Romolo Bazzoni, *60 Anni della Biennale di Venezia*, Venice, 1962, p. 61.

England

Commissioners:
Walter Crane, Alfred East
and George Frampton.
Frank Brangwyn designed
the room and painted four
panels for it; he was
awarded a Gold Medal.
East was president of the
Biennale Jury.

(Paintings, watercolours)
Walter Bayes
Robert Anning Bell
Frank Brangwyn
Henry Harris Brown
J. A. Arnesby Brown
George Clausen
Walter Crane
Alfred East
S. Melton Fisher
Stanhope A. Forbes
Charles W. Furse
Maurice Greiffenhagen
Arthur Hacker
Oliver Hall
James S. Hill
H. Hughes-Stanton
Henry Herbert La Thangue
Moffat Lindner
William Llewellyn
William Mouat Loudan
William Nicholson
A. D. Peppercorn
Bertram Priestman

F. Cayley Robinson
Solomon J. Solomon
Harold Speed
Edward Stott
Henry Scott Tuke
J. W. Waterhouse
Ernest Waterlow
George Frederick Watts

(Sculptures)
Gilbert Bayes
Alfred Drury
George Frampton
J. H. M. Furse
William Goscombe John
William Hamo Thornycroft
Francis Derwent Wood

(Bianco e Nero)
Frank Brangwyn
Frederick Burridge
Edward William Charlton
Alfred East
Henry F. W. Ganz
Robert Goff
Oliver Hall
Charles Holroyd
Sydney Lee
Frank Short
Nathaniel Sparks
Robert Spence
Charles J. Watson
John Wright

International rooms

Maxwell Armfield
James Aumonier
S. Melton Fisher
James Whitelaw Hamilton
John Lavery
Henry Pegram
Louise Perman
F. Cayley Robinson
Byam Shaw
John Terris
David Waterson

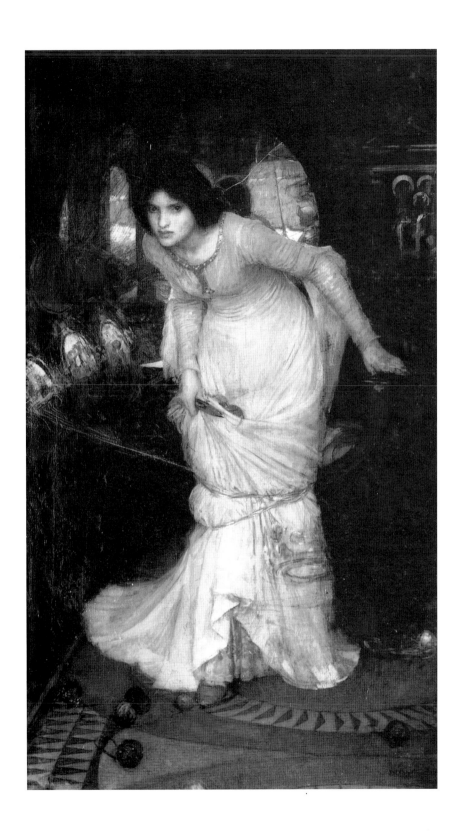

(1905) John William Waterhouse, *The Lady of Shalott*, 1894, oil on canvas, 142.2 x 86.3 cm, Leeds Museums & Galleries, City Art Gallery

7 1907

England

Commissioner:
Frank Brangwyn.
Frank Brangwyn again
designed the room, which
was decorated with the
murals *Venetian
Serenaders*, *Venetian
Commerce*, *Steelworkers*,
Agricultural Labourers.
Brangwyn also served on
the Biennale Jury, and won
a Gold Medal, as did John
Singer Sargent.

(Paintings, watercolours)
George Charles Aid*[6]
Harry Becker
Thomas Austen Brown
Charles Conder
Alfred East
H. Hughes-Stanton
John Lavery
Horace Mann Livens
Mouat Loudan
Harrington Mann
Julius Olsson
James Paterson
Arthur Douglas
 Peppercorn
Bertram Priestman
Tom Robertson
John Singer Sargent*[7]
George Sauter
Mark Senior
George Smith
Grosvenor Thomas

(Sculptures)
George Frampton
Francis Derwent Wood

(Bianco e Nero)
Frank Brangwyn
Alfred East
Joseph Pennell*[8]
John M. Swan

International rooms

(Paintings)
James Whitelaw Hamilton
Archibald Kay
Jos Maggy
John Muirhead
August Neven du Mont
William Orpen*

(Sculptures)
Thomas Stirling Lee

(Bianco e Nero)
Frank Brangwyn
John Wright

L'Arte del Sogno
Walter Crane

[6] Listed as American in 1909.
[7] This was the only occasion on
which Sargent appeared in the
English room; in 1897, 1901,
1903, 1909, 1910 and 1934
(posthumously) he appeared
as American.
[8] Pennell was listed as
American in 1903, 1909 (when
he was on the organising
committee for the American
room) and 1922; he also had a
one-man exhibition of etchings
in 1910, in 1912 showed with
the Senefelder Club, and in
1914 in an international
Bianco e Nero room.

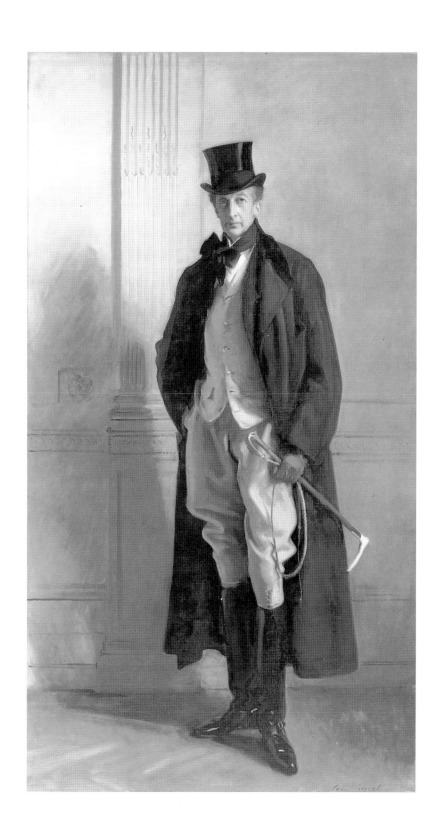

8 1909

British Pavilion

Committee: the Earl of
Plymouth (Chairman),
Lord Montagu of Beaulieu
(Vice-Chairman), Thomas
Lane Devitt, Sam Wilson,
Robert Alfred Workman,
Marcus Bourne Huish
(Treasurer), Paul George
Konody (Secretary).

Architectural Consultant:
E. A. Rickards.

Artistic Sub-Committee:
Frank Brangwyn,
Grosvenor Thomas, Sir
George Frampton.
(Thomas hung the works.)

Brangwyn's designs were
used in the interior of the
Pavilion.

(Paintings)
M. E. Atkins
Robert Anning Bell
T. Austen Brown
Robert Burns
D. Y. Cameron
Gerard Chowne
F. Cadogan Cowper
Mary Davis
Alfred East
John Duncan Fergusson
J. H. Vignoles Fisher
S. Melton Fisher
Sir James Guthrie
Constance Halford
Fred Hall
Oliver Hall
James Whitelaw Hamilton
George Henry
George Houston
Herbert Hughes-Stanton
Robert Gemmell Hutchison
Alexander Jamieson
William Kennedy
George W. Lambert
John Lavery
Horace Mann Livens
William Llewellyn
Albert Ludovici
Charles H. Mackie
William McTaggart
Frank Mura
William Nicholson
William Orpen
Stuart Park

James Paterson
S. J. Peploe
A. D. Peppercorn
Joseph Langsdale
　　Pickering
Bertram Priestman
James Pryde
Edyth Starkie Rackham
Cecil Rea
Alexander Roche
William Rothenstein
Mark Senior
Charles Shannon
Leonard Campbell Taylor
Grosvenor Thomas
Henry Scott Tuke
William Walls
Sir Ernest Waterlow
Terrick Williams
Alfred Withers
Isabelle Dods Withers

(Watercolours)
Charles W. Bartlett
S. J. Lamorna Birch
A. K. Brown
Katharine Cameron
R. McG. Coventry
Romilly Fedden
J. D. Fergusson
William Russell Flint
Albert Goodwin
Peter Alexander Hay
C. A. Hunt
Biddy Macdonald Jamieson

James G. Laing
William Lee-Hankey
Fred Mayor
Robert Buchan Nisbet
Hugh L. Norris
James Paterson
Arthur Rackham
Alexander Wallace
 Rimington
Nora Murray Robertson
T. L. Shoosmith
Frank Short
Fred Stratton
William Walls
Edward A. Walton
Terrick Williams

(Watercolours, Drawings
 and Prints)
Muirhead Bone
Frank Brangwyn
E. C. Austen Brown
Fred Burridge
Axel Herman Haig
Catherine Maude Nichols
G. Spencer Pryse
Frank Short
Joseph Simpson
Charles J. Watson

(Sculptures)
Alfred Drury
Sir George Frampton
Fred W. Pomeroy
Henry Poole
Francis Derwent Wood

(Decorative Art)
Nelson Dawson
Alexander Fisher
The Pilkington's Tile and
 Pottery Co. Ltd.
Ruskin Pottery and Enamel

Works (W. Howson
 Taylor)
Harry Wilson

International rooms
(Sculptures)
Herbert Haseltine

(Bianco e Nero)
Muirhead Bone
Robert Bryden
Fred Burridge
David Cameron
Alfred East
A. Hugh Fisher
Hedley Fitton
R. Goff
Francis Seymour Haden
Hubert von Herkomer
Charles Holroyd
Charles Shannon
Frank Short
E. M. Synge

Note: Illustrations of the
interior of the British Pavilion
in 1909 appear on pp. 20 and 22.

9 1910

British Pavilion

Committee: the Earl of
Plymouth (Chairman),
Lord Montagu of Beaulieu
(Vice-Chairman), Thomas
Lane Devitt, Sam Wilson,
Robert Alfred Workman,
Marcus Bourne Huish
(Treasurer), Paul George
Konody (Secretary).

Architectural Consultant:
E. A. Rickards.

Artistic Sub-Committee:
George Henry, Grosvenor
Thomas, Francis Derwent
Wood. (Thomas hung the
works.)

A painting by John Lavery,
A Lady in Pink, was
purchased for the Galleria
Internazionale d'Arte
Moderna, Venice.

(Paintings)
William Dacres Adams
Robert W. Allan
Sir Lawrence Alma-
 Tadema
M. E. Atkins
Lily Blatherwick
J. A. Arnesby Brown
T. Austen Brown
Andrew Colley
Philip Connard
Frank Dicksee
Alfred East
Betty Fagan
S. Melton Fisher
Robert Fowler
A. Henry Fullwood
W. G. von Glehn
R. Gwelo Goodman
Constance Halford
Oliver Hall
James Whitelaw Hamilton
Archibald Standish
 Hartrick
Alfred Hayward
George Henry
James S. Hill
E. A. Hornel
Francis Howard
Herbert Hughes-Stanton
Gerald Kelly
Laura Knight
George Washington
 Lambert*
Hazel Lavery (née Martyn)

William Logsdail
Harrington Mann
Frank Mura
William Nicholson
William Orpen
Stuart Park
James Paterson
S. J. Peploe
A. D. Peppercorn
Glyn W. Philpot
George Pirie
Bertram Priestman
James Pryde
Cecil Rea
Tom Robertson
Walter Westley Russell
Mark Senior
William Shackleton
Charles Shannon
R. Macaulay Stevenson
Arthur Streeton
Algernon Talmage
Leonard Campbell Taylor
Grosvenor Thomas
J. Alfonso Toft
Edward Arthur Walton
Sir Ernest Waterlow
Alfred Withers
Isabelle Dods Withers

(Watercolours)
Robert Anning Bell
A. K. Brown
James Cadenhead
Katharine Cameron

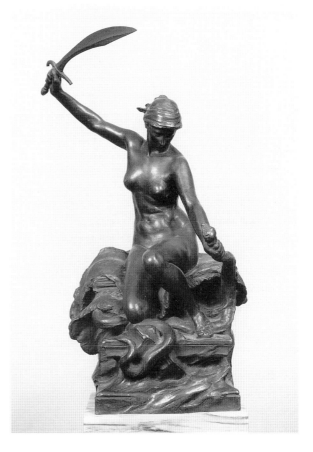

(1910) William Hamo Thornycroft, *Courage*, 1905, (adapted from the sculpture on the Gladstone Memorial in the Strand, London), bronze, 35.5 cm in height, Private collection

Robert McG. Coventry
John P. Downie
Patrick Downie
W. Russell Flint
David Fulton
Ewan Geddes
James Whitelaw Hamilton
George Henry
Thomas Hunt
Mason Hunter
Robert Gemmell Hutchison
James Kay
Harold Knight
Laura Knight
James G. Laing
Charles James Lauder
Alexander MacBride
Tom McEwan
H. C. Preston MacGoun
J. Hamilton Mackenzie
Charles H. Mackie
Finlay Mackinnon
Alex J. Mavrogordato
Fred Mayor
David Neave
Robert Buchan Nisbet
Emily M. Paterson
James Paterson
Arthur Rackham
James Riddel
Vivian Rolt
R. Macaulay Stevenson
Edward Stott
Fred Stratton
John Terris
William Walls
Edward Arthur Walton

(Sculptures)
Gilbert Bayes
Alfred Drury
William Bateman Fagan
Sir George Frampton

Basil Gotto
Charles L. Hartwell
Frank Lynn Jenkins
Leonard Jennings
Thomas Stirling Lee
Harold Parker
Frederick William
 Pomeroy
Melicent Stone
William Hamo Thornycroft
Albert Toft
John Tweed
Francis Derwent Wood

International rooms
(Sculptures)
A. O'Connor

Individual exhibition
John Lavery

Individual exhibition
(Etchings)
Joseph Pennell

69

10 1912

British Pavilion

Committee: the Earl of
Plymouth (Chairman),
Lord Montagu of Beaulieu
(Vice-Chairman), Sir
Kenneth S. Anderson, Sir
David Salomons, Robert
Alfred Workman, Marcus
Bourne Huish (Treasurer),
Paul George Konody
(Secretary).

Architectural Consultant:
E. A. Rickards.

Artistic Sub-Committee:
Gerald Moira, Sir Ernest
Waterlow, Francis
Derwent Wood.

(Paintings)
William Dacres Adams
Anna Airy
Robert W. Allan
Wynne Apperley
Maxwell Armfield
M. E. Atkins
Clare Atwood
Walter Bayes
Oswald Birley
Henry Bishop
Frank Bramley
Horace Brodzky*
Gerard Chowne
Rex Vicat Cole
Philip Connard
Wynford Dewhurst
Walter Donne
Sir Alfred East
Betty Fagan
Hilda Fearon
John Duncan Fergusson
J. H. Vignoles Fisher
Robert Fowler
Roger Fry
Percy F. Gethin
Louis Ginnett
W. G. von Glehn
I.L. Gloag
Maurice Greiffenhagen
Arthur Hacker
Constance Halford
 (Constance Rea)
Oliver Hall
Bernard Harrison

Flora Lion, *My Mother*, 1909, oil on canvas, 127.6 x 114.3 cm, Tate Gallery, London

Alfred Hayward
James Henry
James S. Hill
Charles John Holmes
J. D. Innes
Alexander Jamieson
Augustus E. John
Gerald Kelly
George W. Lambert
Henry Herbert La Thangue
William Leech
Fred Leist
Hayley Lever
Flora Lion
Horace Mann Livens
Ambrose McEvoy
Harrington Mann
W. Westley Manning
Gerald Moira
Tom Mostyn
Julius Olsson
Alfred Parsons
Graham Petrie
Joseph Langsdale Pickering
Arnold Priestman
William Ranken

Cecil Rea
Charles Ricketts
Tom Roberts
Walter Russell
Louis Sargent
Charles Shannon
Walter Sickert
Joseph Simpson
Charles Sims
Adrian Stokes
William Strang
Arthur Streeton
Algernon Talmage
Alfonso Toft
Sir Ernest Waterlow
Alfred Withers
Isabelle Dods Withers
Alfred A. Wolmark

(Watercolours)
Edwin Alexander
Robert W. Allan
Anna Alma-Tadema
Stephen Baghot de la Bere
Robert Anning Bell
Hugh Bellingham-Smith
S. J. Lamorna Birch
Robert H. Buxton
A. Duncan Carse
Nelson Dawson
John Robert Keitley Duff
W. Russell Flint
Douglas Fox Pitt
Albert Goodwin
W. Matthew Hale
Archibald Standish
 Hartrick
Claude Hayes
Arthur Hopkins
James G. Laing
William Lee-Hankey
Moffat Lindner
Robert Little

Mary Howard McClintock
John Muirhead
Robert Buchan Nisbet
Hugh L. Norris
James Paterson
A. Wallace Rimington
F. Cayley Robinson
Claude A. Shepperson
Charles Sims
Arthur Reginald Smith
Robert Thorne Waite
W. Eyre Walker
Sir Ernest Waterlow
J. Walter West
William T. Wood

(Bianco e Nero)
Muirhead Bone
Frank Brangwyn
Frederick Burridge
Frederick Carter
Nelson Dawson
A. Henry Fullwood
Colonel R. Goff
Axel Herman Haig
Alfred Hartley
William Lee-Hankey
Alethea Proctor
George Spencer Watson

(Sculptures)
Gilbert Bayes
Conrad Dressler
Alfred Drury
Charles L. Hartwell
Frederick Brook Hitch
Leonard Jennings
Edouard Lanteri
Thomas Stirling Lee
Courtenay Pollock
Frederick William
 Pomeroy
Henry Poole

Melicent Stone
John Tweed
Arthur George Walker
Charles Wyse

(Decorative Art)
Alfred A. Powell
The Pilkington's Tile and
 Pottery Co. Ltd.

(Jewellery)
Harold Stabler

International rooms
(Paintings)
Ralph R. Latimer**

*Lithographs of the
Senefelder Club,
London*
Anthony R. Barker
Harry Becker
Frank Brangwyn
John Copley
Mary Creighton
Mary Sargant Florence
Ethel Gabain
John McLure Hamilton*9
Archibald Standish Hartrick
E. A. Hope
F. Ernest Jackson
James Kerr-Lawson
Alphonse Legros*
Joseph Pennell
Gerald Spencer Pryse
Charles Shannon
Edmund J. Sullivan
Thomas R. Way
Daniel A. Wehrschmidt

9 Shown in 1899 in the
American room.

11 1914

British Pavilion

Committee: the Earl of Plymouth (Chairman), Lord Montagu of Beaulieu (Vice-Chairman), Edmund Davis, Sir David Salomons, Robert Alfred Workman, Marcus Bourne Huish (Treasurer), Paul George Konody (Secretary).

Architectural Consultant: E. A. Rickards.

Artistic Sub-Committee: Gerald Moira, Arnesby Brown, John Tweed.

(Paintings)
Clare Atwood
Alan Beeton
Robert Anning Bell
J. A. Arnesby Brown
George Clausen
Wynford Dewhurst
Sir Alfred East
Betty Fagan
Alice Fanner
W. G. von Glehn
I. L. Gloag
Stanley Grimm
Charles Napier Hemy
Charles John Holmes
George Houston
Alexander Jamieson
Gerald Kelly
Laura Knight
George W. Lambert
John Lavery
Horace Mann Livens
Harrington Mann
Gerald Moira
David Muirhead
Julius Olsson
George Pirie
Bertram Priestman
William Bruce Ellis
 Ranken
Cecil Rea
Constance Rea
Walter W. Russell
Louis Sargent
James Jebusa Shannon

Charles Sims
Arthur Streeton
Algernon Talmage
Alfonso Toft
George Spencer Watson
Jane Welsh
Mary Wilson
Ethel Wright

(Watercolours, Pastels)
Edwin Alexander
Robert W. Allan
George Owen Wynne
 Apperley
Walter Bayes
Samuel John Lamorna
 Birch
Gerard Chowne
George Clausen
Nelson Dawson
Sir Alfred East
W. Russell Flint
R. Gwelo Goodman
Cecil King
Laura Knight
Moffat Lindner
James McBey
Gerald Moira
Clara Montalba
Hilda Montalba
Emily Paterson
Charles Maresco Pearce
William Bruce Ellis
 Ranken
Alfred William Rich

The Pilkington's Tile and
 Pottery Co. Ltd. –
(G. M. Forsyth, W. S.
 Mycock, R. Joyce, G.
 Rodgers, A. Burton)
Harold Stabler

International rooms
Ralph R. Latimer

(Mostra di Bianco-Nero)
Frank Brangwyn
Joseph Pennell

Individual exhibition
Frank Brangwyn

Individual exhibition
Mary Davis

Frederick Cayley Robinson
Walter W. Russell
George Sheringham
Charles Sims
Hugh Bellingham Smith
Frank Spenlove-Spenlove
Sir Ernest Waterlow

(Sculptures)
Cecil Brown
Basil Gotto
Morris Harding
Evelyn A. Hickman
Frederick William
 Pomeroy
Melicent Stone
Una Trowbridge
Francis Derwent Wood

(Bianco e Nero)
Muirhead Bone
Francis Campbell Boileau
 Cadell
D. Y. Cameron
Frederick Carter
Francis Dodd
Percy F. Gethin
R. G. Goodman
J. Hamilton Hay
Fred Richards
William P. Robins
Joseph Simpson
Edmund J. Sullivan
Emile A. Verpilleux
Harry George Webb

(Decorative Art)
William, Harrison,
 Cowlishaw

12 1920

[Britain did not participate;
the Pavilion was taken
over by the American
section.]

International rooms
Ralph R. Latimer

Poster for the 1920 Venice Biennale

13 1922

British Pavilion
Commissioner:
Frank Brangwyn;
hanging:
James Kerr-Lawson.

(Paintings)
Robert W. Allan
M. E. Atkins
Archibald Barnes
Walter Bayes
Robert Anning Bell
S. J. Lamorna Birch
Henry Bishop
Francis Black
D. Y. Cameron
Estella Canziani
Edward Chappel
George Clausen
Isabel Codrington
Francis Henry Crittall
Mary Davis
Isabelle Dods-Withers
S. Melton Fisher
W. Mark Fisher
W. Russell Flint
Stanhope A. Forbes
Mark Gertler
Charles Ginner
Walter Greaves
Orlando Greenwood
Allan Gwynne-Jones
Oliver Hall
George Harcourt
Dudley Hardy
Archibald Standish
 Hartrick
James Henry
Edith A. Hope
Herbert Hughes-Stanton
Cecil Arthur Hunt

Augustus John
Gerald Kelly
Eric H. Kennington
J. Kerr-Lawson
Laura Knight
Sir John Lavery
William Lee-Hankey
Flora Lion
Horace Mann Livens
Mouat Loudan
Mary McCrossan
Bernard Meninsky
Gerald Moira
Harry Morley
John Nash
William Nicholson
Julius Olsson
C. Maresco Pearce
Glyn Philpot
Dod Procter
Ernest Procter
James Pryde
Leonard Richmond
H. Davis Richter
Ethel Sands
Michael Sevier
William Shackleton
George Sheringham
Walter Sickert
Frank Spenlove-Spenlove
Adrian Stokes RA
Ian Strang
William Strang
Alexander Stuart-Hill
Leslie Thomson

(1922) George Frampton, *Peter Pan*, 1915, (a reduction of the central figure from the sculpture in Kensington Gardens, London), bronze, 53 cm in height, cast in a Private Collection: courtesy Sotheby's, London

William Lee-Hankey
H. Macbeth-Raeburn
Harold Nelson
C. R. W. Nevinson
Malcolm Osborne
C. Maresco Pearce
Barry Pittar
Gerald Spencer Pryse
Raymond Ray-Jones
Warwick Reynolds
William P. Robins
George Herbert Rose
C. Shannon
George Soper
Leonard R. Squirrell
F. S. Unwin
Ernest Wallcousins
Leslie Moffat Ward
R. Douglas Wells
J. Walter West

Ethel Walker
George Spencer Watson
Harry Watson
Madeline Wells
J. Walter West
Alfred Withers
Alfred Wolmark
Jack B. Yeats

(Sculptures)
Gilbert Bayes
Alfred Drury
Alexander Fisher
Sir George Frampton
Francis Sargant**
A. G. Walker

(Bianco e Nero)
John Austen

A. R. Barker
Charles H. Baskett
Alfred Bentley
E. Blampied
Muirhead Bone
Christopher Clark
Frank L. Emanuel
Hanslip Fletcher
Annie Frenck
Ethel Gabain
Madeline Green
Herbert Hampton
Martin Hardie
George Harrison
Kenneth Hobson
Augustus John
Ernest Borough Johnson
Esther Borough Johnson
Dorothea Landau (Da Fano)

14 1924

British Pavilion

Organised by the Faculty of Arts.[10] Organising committee: Lord Montagu of Beaulieu (Chairman), Lady Cunard, Lord Lee of Fareham, Sir Philip Sassoon, Sir John A. Cockburn, Edmund Davis, P. G. Konody (Secretary).

Artistic Commission: Charles Sims, Laura Knight, Kennedy North.

[10] A federation of artists promoting public interest in the arts.

(Paintings)

Adrian Paul Allinson
Maxwell Armfield
Nathaniel Hughes John Baird
A. G. Baker
Archibald Barnes
Robert Bevan
A. E. Bottomley
J. A. Arnesby Brown
F. C. B. Cadell
Richard Carline
Edward Chappel
J. Cosmo Clark
Isabel Codrington
Philip Connard
W. Conor
J. E. Cowlman
N. L. M. Cundell
Marion Dawson
John Everett
Claude Flight
S. Gausden
Mark Gertler
Duncan Grant
Orlando Greenwood
Harold Harvey
E. Q. Henriques
Paul Henry
Sir Charles John Holmes
Gladys Hynes
S. de Karlowska
Gerald Kelly
Clara Klinghoffer
Harold Knight

Laura Knight
J. Blair Leighton
A. Neville Lewis
Mary McCrossan
Margaret Macdonald Mackintosh
Gerald Moira
Tom Mostyn
A. J. Munnings
C. R. W. Nevinson
William Nicholson (22 works)
J. C. Peploe
Glyn Philpot
L. Pilichowski
W. B. E. Ranken
E. H. Handley Read
Leonard Richmond
H. Davis Richter
E. M. Rummel
Michael Sevier
Charles Sims
A. Talmage
W. H. Y. Titcomb
Ann Fearon Walke
Ethel Walker
Marjorie Watson-Williams [later Paule Vézelay]
N. Wilkinson
Alfred A. Wolmark

(Watercolours)

William Dacres Adams
Adrian Paul Allinson
Hylda M. Atkins

(1924) William Nicholson, *Sports on the Cedric*, 1921, oil on canvas board, 63.5 x 52 cm, Private Collection: courtesy Browse & Darby, London

Nathaniel Hughes J. Baird
A. G. Baker
Robert Bevan
H. M. Coley
Charles John Collings
Frank Dobson
Vera Down
Rosalie Emslie
W. E. Hardiman
Cecil King
Clara Klinghoffer
Menie Knight
Malcolm Milne
Paul Nash
Emily M. Paterson
Maresco Pearce
Lucien Pissarro*
Bertram Priestman
William Ratcliffe
Randolph Schwabe

Arthur Winter Shaw
Cumbrae Stewart
Walter Taylor
Walter Tyndale
William Walcot
G. Watson
Ethelbert White
Alfred A. Wolmark

(Sculptures)
Frank Dobson
Henri Gaudier-Brzeska*

(Bianco e Nero)
William Douglas Almond
Stanley Anderson
John D. Batten
Mary Berridge
E. C. Austen Brown
Ada L. Collier

Miriam Deane
John Everett
F. Morley Fletcher
Ethel Found
William Giles
John Frederic Greenwood
Cicely Griffiths
S. Fred Haines
Martin Hardie
Alfred Hartley
Robertine Heriot
F. Ernest Jackson
Margarite Janes
Ethel Kirkpatrick
Laura Knight
Charlotte Lawrenson
E. L. Lawrenson
W. Monk
C. R. W. Nevinson
W. J. Phillips
John Platt
Hilda Porter
A. Rigden Read
G. Woolliscroft Rhead
Raphael Roussel
Théodore Roussel*
M. A. Royds
Allen W. Seaby
A. M. Shrimpton
Y. Urushibara
Emile Verpilleux
Marjorie Watson-Williams
Gerard de Witt

(Decorative Art)
Carter, Stabler & Adams
Edith Linnell
W. Staite Murray
Henry T. Wyse

International rooms
Jessie Boswell**

79

15 1926

British Pavilion
No Selection Committee
listed in the Biennale
catalogue.

Commissioners:
Frank Dobson (President
of the London Group) and
P. G. Konody.

(Paintings)
Bernard Adeney
Adrian Paul Allinson
Archibald G. Barnes
Walter Bayes
Keith Baynes
Alan Beeton
Robert Anning Bell
Vanessa Bell
S. J. Lamorna Birch
E. Beatrice Bland
Reginald Grange Brundrit
Richard Carline
William L. Clause
Isabel Codrington
Philip Connard
Charles Cundall
Stefani Melton Fisher
Roger Fry
Mark Gertler
W. G. de Glehn
Duncan Grant
Allan Gwynne-Jones
Fairlie Harmar
Frederick Leverton Harris
Grace Henry
Edgar Hereford
Sir Charles John Holmes
Pat Hope-Nelson
Rudolph Ihlee
Eric Kennington
Sir John Lavery
Edward Bernard Lintott
Otway McCannell
Bernard Meninsky

M. F. de Montmorency
Alfred J. Munnings
John Nash
Paul Nash
Algernon Newton
Bertram Nicholls
Sir William Orpen
Frederick Porter
Bertram Priestman
Dod Procter
Ernest Procter
William Ranken
Anne Estelle Rice
Herbert Davis Richter
Walter Westley Russell
Albert Rutherston
Randolph Schwabe
Elliott Seabrooke
Michael Sevier
Frederic H. S. Shepherd
Walter Richard Sickert
Charles Simpson
Matthew Smith
A. Stuart-Hill
Annie Swynnerton
A. R. Thomson
Allan Walton
Marjorie Watson-Williams
Terrick Williams
Edward Wolfe
Alfred Wolmark

(1926) Paul Nash, *The Sea,* 1923, oil on canvas, 55.8 x 88.9 cm, The Phillips Collection, Washington, DC

(Watercolours)
William Dacres Adams
Gerald Arbuthnot
Lamorna Birch
Arthur Briscoe
Charles M. Gere
W. G. de Glehn
Alfred Hayward
D. Sutherland MacColl
Freda Marston
Algernon Newton
C. Maresco Pearce
William Ranken
Walter Westley Russell
Elliott Seabrooke
A. Reginald Smith
P. Wilson Steer
W. Tryon
Walter Tyndale
Edward Wadsworth

William Walcot
Harry Watson
J. Walter West
Ethelbert White
William Wood
Richard Wyndham

(Sculptures)
William Reid Dick
Frank Dobson
Maurice Lambert

(Bianco e Nero)
Stanley Anderson
Frank Brangwyn
G. L. Brockhurst
H. J. Stuart Brown
Hester Frood
Roger Fry
Elizabeth Fyfe

Eric Gill
Martin Hardie
Norman Janes
E. S. Lumsden
James McBey
Donald Shaw MacLaughlan
Job Nixon
W. P. Robins
Walter Sickert
Walter Taylor

(Decorative art)
Stella R. Crofts
W. Staite Murray

International rooms
Jessie Boswell
Maud Maquay**
Mary Pollitt Morrison**
Francis Sargant

16 1928

British Pavilion

Committee: Lord Montagu
of Beaulieu (Chairman),
Charles Aitken, Lady
Cunard, Sir Joseph
Duveen, Sir Philip Sassoon,
Lord Ivor Spencer-
Churchill, P. G. Konody
(Secretary).
Organised by British
Artists' Exhibitions,
founded by Duveen, of
which Sir Martin Conway
was President and Sir
Robert Witt Vice-President
of the Executive
Committee.

Artistic Committee: Sir
William Orpen (President),
Charles H. Collins Baker,
Gerald Brockhurst, Philip
Connard, William Reid
Dick, Jacob Epstein, Roger
Fry, Augustus John,
Randolph Schwabe, Adrian
Stokes R.A.

Members of the British
jury: Gerald Brockhurst,
Philip Connard, William
Reid Dick.

(Individual Exhibitions of)
Sir William Orpen
Augustus John
A. K. Lawrence
Frank Dobson
W. Reid Dick

(also Paintings by)
John Armstrong
Clare Atwood
Keith Baynes
Vanessa Bell
E. Beatrice Bland
D. Bomberg
J. A. Arnesby Brown
Charles S. Cheston
Evelyn Cheston
Sir George Clausen
Philip Connard
Charles Cundall
N. L. M. Cundell
Thomas Cantrell Dugdale
John Duncan Fergusson
William Russell Flint
Roger Fry
Charles Ginner
Ronald Gray
H. James Gunn
Oliver Hall
Ivon Hitchens
Sir Charles John Holmes
Sir Herbert Hughes-
 Stanton
E. Borough Johnson
Gerald Kelly

Henry Lamb
Sir John Lavery
Neville Lewis
Thomas Lowinsky
Dugald Sutherland
 MacColl
W. T. Monnington
Harry Morley
Cedric Morris
David Muirhead
Alfred J. Munnings
John Nash
Paul Nash
William Nicholson
Winifred Nicholson
Glyn Philpot
Louise Pickard
Lucien Pissarro
Bertram Priestman
Dod Procter
Ernest Procter
William Roberts

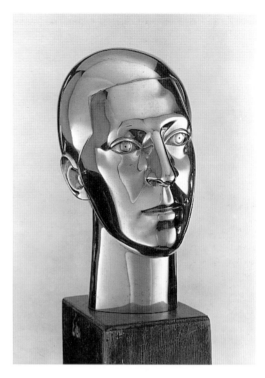

Frank Dobson, *Sir
Osbert Sitwell*, 1922,
bronze, 31.8 cm in
height, cast in Tate
Gallery, London

William Rothenstein

W. W. Russell

Walter Richard Sickert

Charles Sims

Matthew Smith

Gilbert Spencer

Stanley Spencer

Philip Wilson Steer

L. Campbell Taylor

Henry Tonks

Ethel Walker

Ethelbert White

(1928) Winifred Nicholson, *Window-Sill, Lugano*, 1923, oil on board, 28 x 50 cm, Tate Gallery, London

(Watercolours and Drawings)

Elsie Atkins

Charles S. Cheston

David Jones

Dugald Sutherland MacColl

Paul Nash

Fred Pegram

Albert Rutherston

Rowley Smart

(Sculptures)

Gilbert Bayes

Alexander Carrick

Alan L. Durst

Jacob Epstein

John Duncan Fergusson

Alfred F. Hardiman

Vernon Hill

Allan Howes

Charles Sargeant Jagger

Maurice Lambert

William McMillan

Leonard Stamford Merrifield

Alfred James Oakley

Francis Sargant

John Skeaping

Frank Mowbray Taubman

Albert Toft

Alfred Turner

John Tweed

Arthur George Walker

Edwin Whitney-Smith

(Bianco e Nero)

Stanley Anderson

Winifred Austen

Frederick G. Austin

Robert S. Austin

Charles H. Baskett

Edmund Blampied

Douglas Percy Bliss

Muirhead Bone

Stephen Bone

Arthur Briscoe

Gerald Leslie Brockhurst

Charles S. Cheston

Sir George Clausen

Francis Dodd

Paul Drury

John Robert Keitley Duff

Sylvia Gosse

James Grant

John Frederic Greenwood

Barbara Greg

Martin Hardie

Herbert Johnson Harvey

Gertrude Hermes

Vernon Hill

Blair Hughes-Stanton

Norman Janes

David Jones

Helen Kapp

Laura Knight

Sydney Lee

James McBey

Allan McNab

John Nash

Paul Nash

C. R. W. Nevinson

Job Nixon

Agnes Miller Parker

Lucien Pissarro

Eric Ravilious

William Palmer Robins

Henry Rushbury

Randolph Schwabe

Walter Richard Sickert

Joseph Simpson

Ian Strang

C. W. Taylor

A. R. Middleton Todd

Ethelbert White

Mostra dell'Arte del Teatro

Cecil Beaton

International rooms

Jessie Boswell

Herbert Gurschner*

Daphne Maugham

83

17 1930

British Pavilion

Under the patronage of
H.M. Government for the
first time.
Organising Committee:
Charles Aitken, Sir Cyril
Kendall Butler, Evan
Charteris, Lord Ivor
Spencer-Churchill, Lady
Cunard, Sir Joseph
Duveen, Edward Marsh,
Evan Morgan, Sir Philip
Sassoon, Richard
Wyndham, P. G. Konody
(Secretary).

Members of the British
jury: Allan Gwynne-Jones,
J. B. Manson, Glyn Philpot.

(Individual Exhibitions of)
Glyn Philpot
William Rothenstein
Walter Richard Sickert
Jacob Epstein
Heri Moore [sic]
John Skeaping

(also Paintings by)
Adrian Paul Allinson
E. Constable Alston
M. Baldwin-Griffith
Walter Bayes
Vanessa Bell
Henry Bishop
Edmund Blampied
E. Beatrice Bland
David Bomberg
Rodney Joseph Burn
William L. Clause
Sir George Clausen
Philip Connard
Charles Cundall
Nora L.M. Cundell
Adrian Daintrey
Francis Dodd
C. Brooke Farrar
J. D. Fergusson
Vivian Forbes
Barnett Freedman
Roger Fry
Charles Genge
Eric George
Mark Gertler
Colin Gill

Charles Ginner
Duncan Grant
Herbert Gurschner
Allan Gwynne-Jones
Fairlie Harmar
Alfred Hayward
Sir Charles John Holmes
G. Leslie Hunter
Alexander Jamieson
Gerald Kelly
Henry Lamb
Thomas Lowinsky
Mary McCrossan
Sine Mackinnon
Philip Maclagan
J. B. Manson
Malcolm Milne
Harry Morley
Cedric Morris
Paul Nash
C. R. W. Nevinson
Bertram Nicholls
William Nicholson
S. J. Peploe
Lucien Pissarro
Frederick Porter
Dod Procter
Ernest Procter
Charles Ricketts
William Roberts
M.K. Rowles
Albert Rutherston
Michael Sevier
Matthew Smith
Gilbert Spencer

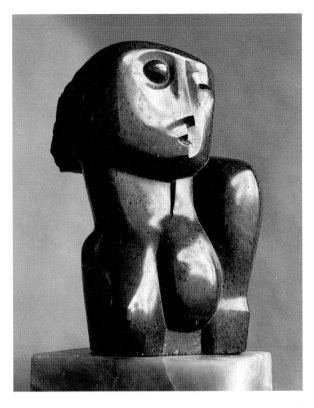

(1930) Henry Moore, *Head and Shoulders*, 1927, verde di prato, 45.7 cm in height, Private collection: courtesy Michael Hue-Williams, London

William Rothenstein
Henry Rushbury
Albert Rutherston
Randolph Schwabe
Gilbert Spencer
Ian Strang
Walter Tyndale
Ethel Walker
Hubert Wellington
Bassett Wilson

International rooms
Jessie Boswell
Herbert Gurschner
Philip A. De Laszlo*
Daphne Maugham
Francis Sargant

Mostra Internazionale dell'Orafo
Included a British group of goldsmiths

Stanley Spencer
P. Wilson Steer
Alexander Stuart-Hill
Henry Tonks
Ethel Walker
Hubert Wellington
Muriel Wilson

(Watercolours, Bianco e Nero)
Stanley Anderson
Frederick G. Austin
Robert Austin
Edmund Blampied
Muirhead Bone
Gerald L. Brockhurst
Rodney Joseph Burn
George Charlton
Charles S. Cheston
Sir George Clausen

Francis Dodd
Richard Eurich
Mary Sargant Florence
Eric Gill
Robin Guthrie
Allan Gwynne-Jones
Alfred Hayward
Sir Charles John Holmes
Augustus John
Henry Lamb
Iain Macnab
Malcolm Milne
William E. C. Morgan
Harry Morley
David Muirhead
John Nash
Paul Nash
C. R. W. Nevinson
Job Nixon
Malcolm Osborne

18 1932

British Pavilion

Organised by the
Department of Overseas
Trade.
Selection Committee:
Sir Charles Holmes
(Chairman), Edward
Marsh, J. B. Manson,
Martin Hardie, C. L.
Stocks, Alfred A. Longden,
Campbell Dodgson,
Francis Dodd, W. M. Hill
(Secretary).

(Individual exhibition of)
Ambrose McEvoy

(also Paintings by)
Sir George Clausen
Philip Connard
Duncan Grant
Augustus John
Gerald Kelly
Henry Lamb
Bernard Meninsky
Cedric Morris
Alfred J. Munnings
John Nash

Paul Nash
William Roberts
Walter Richard Sickert
Matthew Smith
Stanley Spencer
Philip Wilson Steer
Edward Wadsworth
Ethel Walker

(Sculptures)
Frank Dobson
Eric Gill
John Skeaping

(Bianco e Nero)
Robert Austin
Muirhead Bone
Gerald Leslie Brockhurst
Sir George Clausen
Frank Dobson
Eric Gill
Augustus John
Bernard Meninsky
John Nash
Paul Nash
John Skeaping
Stanley Spencer
Philip Wilson Steer

Mostra delle Riviste d'Arte Moderna

Included a British group
(*The Studio*, *Apollo*,
Commercial Art and *The
Orbit*)

Walter Richard
Sickert, *The Bridge of
Sighs*, *c.*1901, oil on
canvas, 36.2 x 31.8
cm, Private collection

(1932) Eric Gill, *Deposition,* 1924, black marble, 76.2 cm in height, The King's School, Canterbury

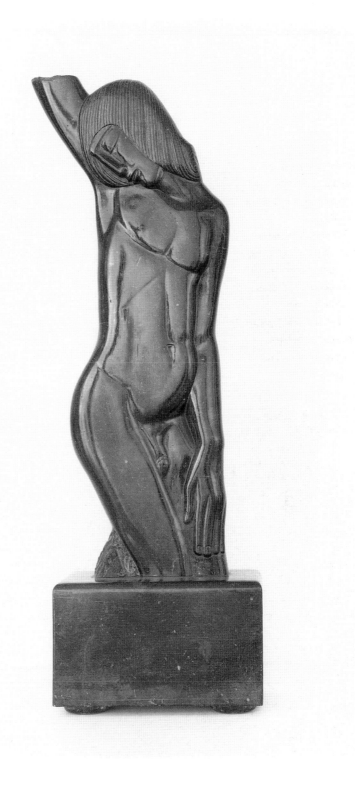

British Pavilion
Organised by the
Department of Overseas
Trade.
Selection Committee:
J. B. Manson (Chairman),
Francis Dodd, Campbell
Dodgson, C. L. Stocks,
Martin Hardie,
A. A. Longden, Edward
Marsh, W. M. Hill
(Secretary), S. Cooper
(Vice-Secretary).

(Paintings)
John Aldridge
Vanessa Bell
J. A. Arnesby Brown
Charles Cundall
R. O. Dunlop
Charles R. Gerrard
Ian D. Campbell Gray
Oliver Hall
J. D. Innes
David Jones
C. R. W. Nevinson
Algernon Newton
Ben Nicholson
Winifred Nicholson
Frederick Porter
James Pryde
Albert Rutherston
Ethelbert White

(Sculptures)
William Reid Dick
Maurice Lambert

(Watercolours)
J. D. Innes
David Jones
P. H. Jowett
Claude Muncaster
Frederick Porter
Henry Rushbury
Albert Rutherston

(Bianco e Nero)
F. L. M. Griggs
Oliver Hall
Clare Leighton
Orovida Pissarro
James Pryde
Ethelbert White

*Mostra
Internazionale del
Ritratto dell'800*
*[International Exhibition of
the 19th Century Portrait]*
(including the following
British artists)
Ford Madox Brown
John Downman
William Dyce
Charles Wellington Furse
Andrew Geddes
Sir James Guthrie
Frank Holl
William Holman Hunt
Charles Keene
Sir Edwin Landseer
Sir Thomas Lawrence
Ambrose McEvoy
Sir Daniel Macnee
Benjamin Marshall
Sir John Everett Millais
John Opie
Sir William Quiller
 Orchardson
Sir William Orpen
Sir Henry Raeburn

(1934) Ben Nicholson, *Design,* 1933, oil on board, 25.4 x 51.6 cm, Tyne and Wear Museums, Laing Art Gallery, Newcastle upon Tyne

George Richmond

Sir William Blake
 Richmond

Dante Gabriel Rossetti

Frederick Sandys

Alfred Stephens

William Strang

George Frederick Watts

Sir David Wilkie

[Britain did not exhibit
officially.]

*Mostra degli Stranieri
Residenti in Italia ed
Altri*
(held in the British
Pavilion)
Andrea Beleborodoff
Frank Brangwyn
R. O. Dunlop
Sir Alfred Gilbert
Duncan Grant
E. Hawthorne
Barbara Hepworth
Augustus John
Derwent Lees
Bernard Meninsky
Cedric Morris
John Nash
S. J. Peploe
Beryl Reid
William Bernard Reid
Francis Sargant
Walter Sickert
John Skeaping
Gilbert Spencer
P. Wilson Steer
W. J. Steggles
Anne Strauss
Cecilia Sturt
William Walcot
Ethel Walker

Mostra del Libro
included Frank Brangwyn,
John Farleigh, Charles
Ricketts, William Walcot

Poster for the 1936 Venice Biennale

The prize for a foreign engraver was won by Blair Hughes-Stanton.

British Pavilion

The British Council took over the British Pavilion at this Biennale.
Selection Committee:
Sir Lionel Faudel-Phillips (Chairman), Lord Balniel, Sir Kenneth Clark, Campbell Dodgson, Sir Edward Marsh.

Commissioner:
Alfred A. Longden.

Paul Nash
Matthew Smith
Stanley Spencer
Christopher Wood
Jacob Epstein
Stanley Anderson
Blair Hughes-Stanton

Mostra Internazionale del Paesaggio del Secolo XIX
[International Exhibition of the 19th Century Landscape]
Richard Wilson
Thomas Gainsborough

John Crome
John Constable
J. M. W. Turner
David Roberts
George Robert Lewis
John Linnell
James Sant
Alfred Clint

Blair Hughes-Stanton, *The Mighty Angel*, 1933, wood engraving, 21 x 12.5 cm, British Council Collection, London

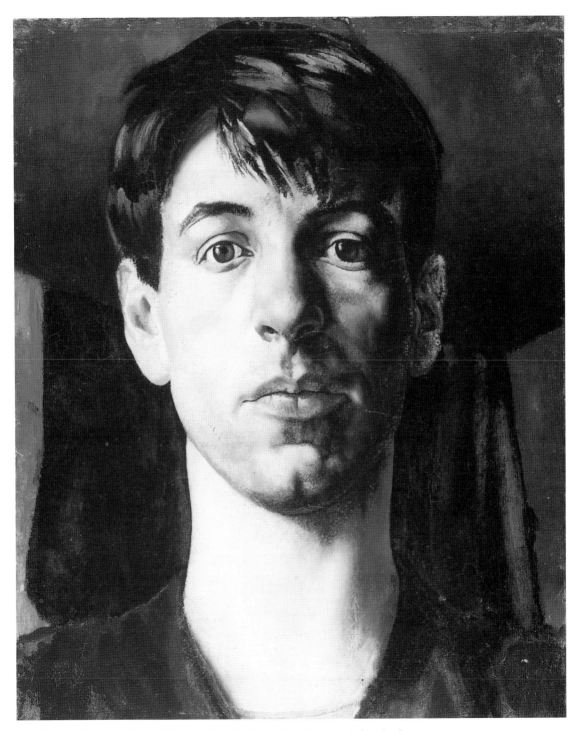

(1938) Stanley Spencer, *Self-Portrait*, 1913, oil on canvas, 62.9 x 50.8 cm, Tate Gallery, London

22 1940

[Britain did not exhibit officially.

An exhibition of the works selected for the Biennale but withdrawn at a late stage was held by the British Council at Hertford House, London (the Wallace Collection) in May-June 1940. The artists selected were Frank Dobson, A. J. Munnings, the late Glyn Philpot, Edward Wadsworth, Frances Hodgkins and Duncan Grant; a group of wood engravings was also shown. The Selection Committee consisted of Sir Lionel Faudel-Phillips (Chairman), Clive Bell, Campbell Dodgson, Lawrence Haward, Sir Eric Maclagan, Herbert Read, the Earl of Sandwich, and Alfred Longden (Secretary).]

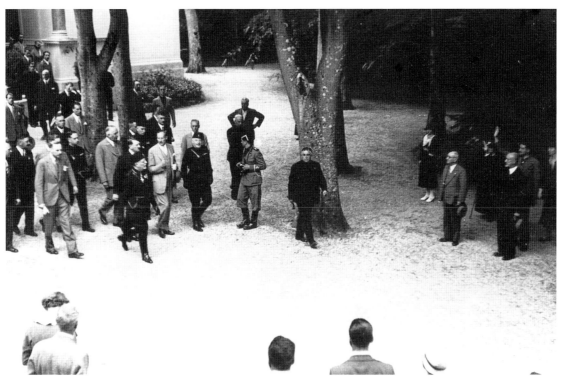

Hitler outside the British Pavilion, having visited the German Pavilion, during his visit to the 1934 Biennale

23 1942

[Britain did not exhibit
officially; the British
Pavilion was taken over by
the Italian army, becoming
the Padiglione del Regio
Esercito (Royal Army
Pavilion) (see illustration
opposite). A mural
decorated the loggia.]

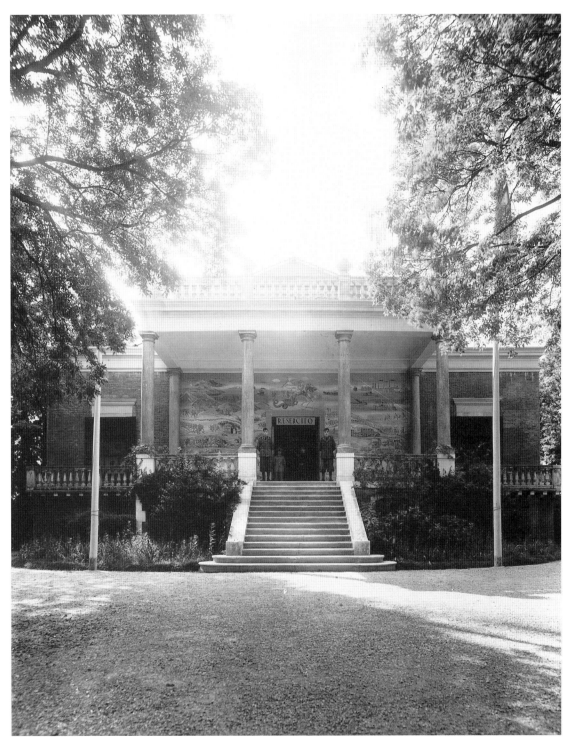

(1942) The British Pavilion occupied by the Italian Army

Henry Moore won the
International Sculpture
Prize.

British Pavilion
Fine Arts Committee of the
British Council: Sir Eric
Maclagan (Chairman),
Leigh Ashton, Clive Bell,
Prof. T. S. R. Boase,
Colonel Gerald Coke, Prof.
W. G. Constable, Campbell
Dodgson, Philip Hendy,
Philip James, Sir Edward
Marsh, Sir Owen
Morshead, Herbert Read,
John Rothenstein,
Viscount Tredegar, the
Duke of Wellington, Allan
Walton, John Witt, Francis
Watson (Director, Visual
Art Department, British
Council), Lilian Somerville
(Head, Fine Art Section).

There was no Selection
Committee.

Commissioner for the
British Pavilion:
John Rothenstein.

J. M. W. Turner
Henry Moore

*Works from the
Peggy Guggenheim
collection*
Henry Moore
Ben Nicholson
John Tunnard

(1948) Henry Moore holding *Stringed Figure*, 1937

British Pavilion

Selection Committee:
Sir Eric Maclagan,
Sir Philip Hendy, John
Rothenstein, Herbert Read.

Director, Fine Arts
Department, British
Council: Lilian Somerville.

Commissioner for the
Pavilion: Sir Eric Maclagan.

John Constable
Matthew Smith
Barbara Hepworth

**John Constable
exhibition**

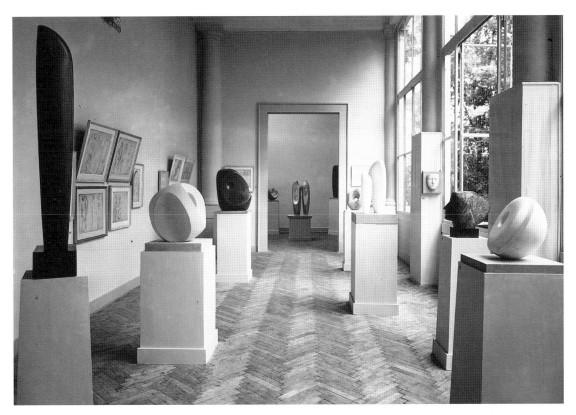

(1950) Barbara Hepworth exhibition

26 1952

Graham Sutherland won the Acquisition Prize of the São Paulo Museu de Arte Moderna, Brazil for *Twisted Tree Form*, 1944.

Sir John Rothenstein was on the International Committee of Experts.

British Pavilion
Selection Committee:
Sir Philip Hendy, Herbert Read, Sir John Rothenstein, Lilian Somerville.

Commissioner:
Herbert Read.

Graham Sutherland
Edward Wadsworth

New Aspects of British Sculpture:
Robert Adams
Kenneth Armitage
Reg Butler
Lynn Chadwick
Geoffrey Clarke
Bernard Meadows
Henry Moore
Eduardo Paolozzi
William Turnbull

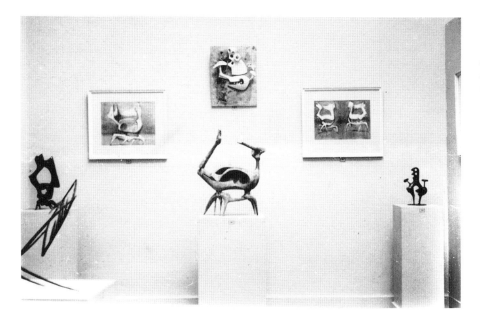

New aspects of British sculpture (the "geometry of fear") exhibition. Sculpture and works on paper by Bernard Meadows

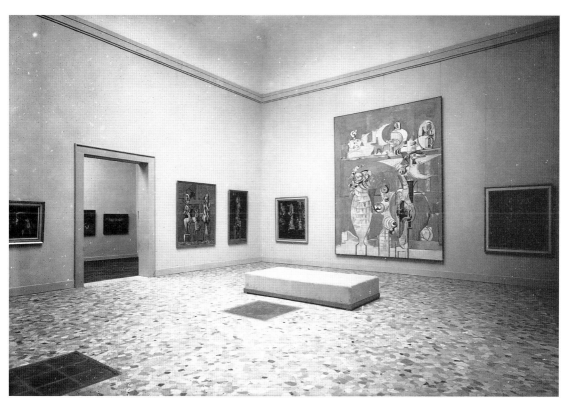

(1952) Graham Sutherland exhibition

Ben Nicholson won the
Ulisse Prize.

British Pavilion

Selection Committee:
Sir Philip Hendy, Philip
James, Roland Penrose,
Sir Herbert Read, Sir John
Rothenstein, Lilian
Somerville.

Ben Nicholson
Francis Bacon*
Lucian Freud*

Reg Butler (works relating
to his *Unknown Political
Prisoner*)

(Lithographs)
Allin Braund
Geoffrey Clarke
Henry Cliffe
Robert Colquhoun,
William Gear
Henry Moore
Eduardo Paolozzi
Ceri Richards
William Scott
Graham Sutherland

Francis Bacon,
Painting, 1946, oil
and pastel on linen,
197.8 x 132.1 cm,
The Museum of
Modern Art, New
York

(1954) Ben Nicholson, *1949. December 5 (poisonous yellow)*, 1949, oil and pencil on canvas, 124.4 x 162.4 cm, Galleria d'Arte Moderna, Ca' Pesaro, Venice. Acquired from the Biennale

Lucian Freud, *Girl with Roses*, 1947-48, oil on canvas, 106 x 75 cm, British Council Collection, London

Lynn Chadwick won the International Sculpture Prize.

British Pavilion
Selection Committee:
Sir Philip Hendy, Sir John Rothenstein, Roland Penrose, Sir Herbert Read, Lilian Somerville.

Commissioner:
Sir Herbert Read
Assistant Commissioner:
Lilian Somerville.

Ivon Hitchens
Lynn Chadwick

Four Young Painters:
John Bratby
Derrick Greaves
Edward Middleditch
Jack Smith

Exhibition of foreign artists resident in Italy
J. Duncan

Ivon Hitchens exhibition

Four Young Painters exhibition. Paintings by John Bratby (left wall)

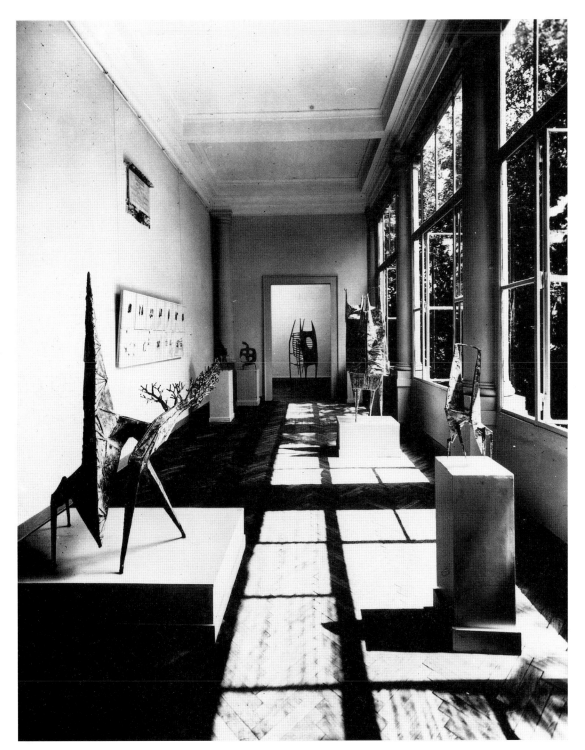

(1956) Lynn Chadwick exhibition

29 1958

S. W. Hayter won first prize for a religious work, and Kenneth Armitage won the David E. Bright Foundation Prize for a sculptor under 45.

S. W. Hayter
William Scott
Kenneth Armitage

British Pavilion

Selection Committee:
Sir Philip Hendy,
Sir Herbert Read,
J. M. Richards, Sir John
Rothenstein, Lilian
Somerville.

Commissioner:
Sir Philip Hendy
Assistant Commissioner:
Lilian Somerville.

Sezione Giovani

Sandra Blow, Alan Davie,
Anthony Caro

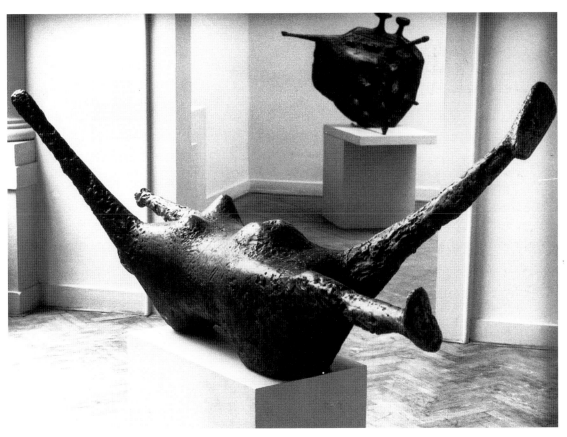

(1958) Kenneth Armitage exhibition. *Sprawling Woman*, 1957 (foreground), *Two Seated Figures*, 1957 (rear)

Eduardo Paolozzi won the
David E. Bright Foundation
Prize for a sculptor under
45.
Sir Herbert Read was on
the International Jury and
the International
Committee of Experts.

British Pavilion

Selection Committee:
Sir Philip Hendy, Roland
Penrose, Sir Herbert Read,
Sir John Rothenstein,
Lilian Somerville.

Commissioner:
Lilian Somerville.

**Victor Pasmore
Eduardo Paolozzi
Geoffrey Clarke
Henry Cliffe
Merlyn Evans**

Victor Pasmore (right) with Ben Nicholson in Victor Pasmore's exhibition

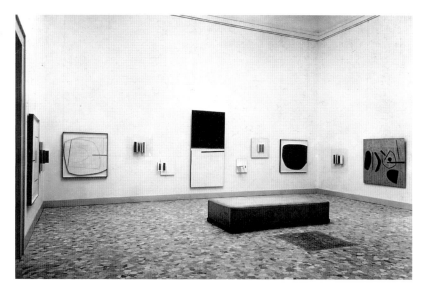

Installation of Victor Pasmore exhibition

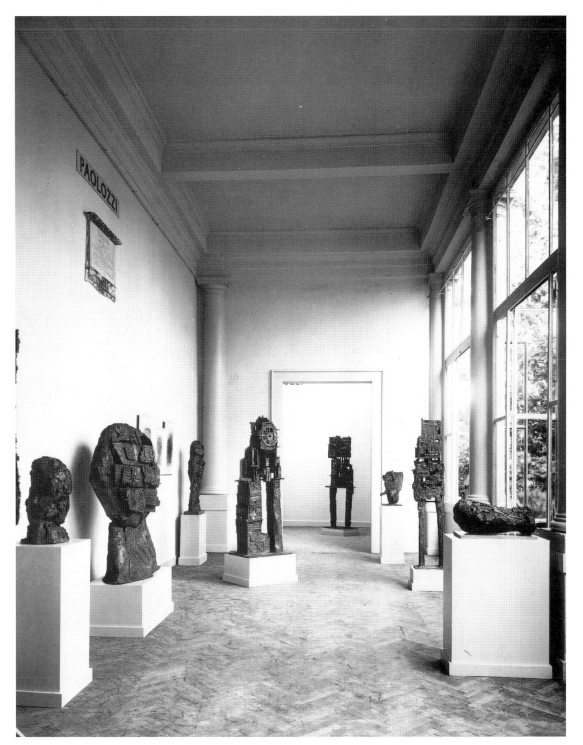

(1960) Eduardo Paolozzi exhibition

31 1962

Hubert Dalwood won the David E. Bright Foundation prize for a sculptor under 45; Ceri Richards won the Guilio Einaudi prize. Sir Philip Hendy was on the International Jury.

Robert Adams
Hubert Dalwood
Ceri Richards

British Pavilion

Selection Committee: Sir Philip Hendy, Alan Bowness, Roland Penrose, Sir Herbert Read, J. M. Richards, Sir John Rothenstein, Lilian Somerville.

Commissioner: Lilian Somerville.

Robert Adams and Ceri Richards (right) in Ceri Richards' exhibition

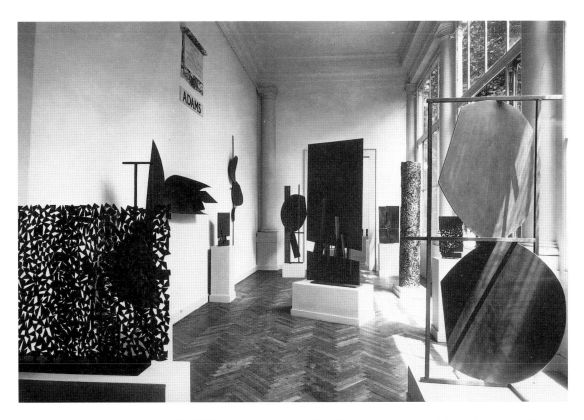

**Above: (1962) Robert
Adams exhibition**

**Right: Hubert
Dalwood sculpture**

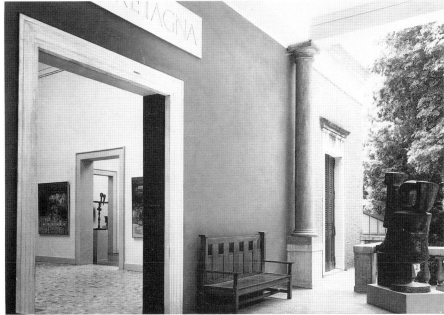

Roger Hilton was awarded the UNESCO prize.

British Pavilion
Selection Committee:
Sir Philip Hendy, Alan Bowness, Roland Penrose, Sir Herbert Read, J. M. Richards, Sir John Rothenstein, Lilian Somerville.

Commissioner:
Lilian Somerville.

Roger Hilton
Bernard Meadows
Gwyther Irwin
Joe Tilson

Arte d'oggi nei musei
works by Robert Adams, Kenneth Armitage, Francis Bacon, Lynn Chadwick, Harold Cohen, Alan Davie, Lucian Freud, Stephen Gilbert, Barbara Hepworth, Ivon Hitchens, Ronald Kitaj*, Henry Moore, Ben

Nicholson, Eduardo Paolozzi, Victor Pasmore, Ceri Richards, William Scott, Graham Sutherland

Gwyther Irwin

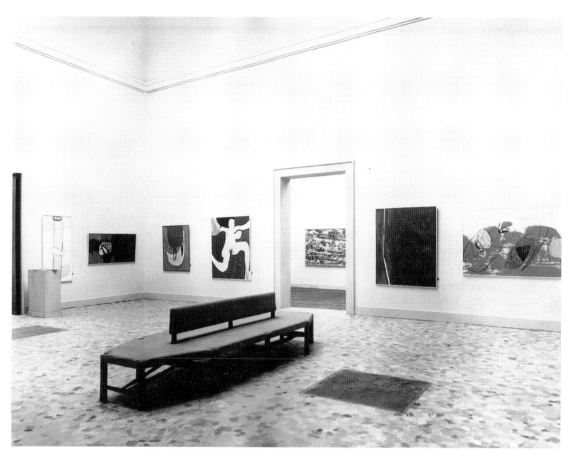

**Above: (1964) Roger
Hilton exhibition**

**Right: Joe Tilson
exhibition**

33 1966

Anthony Caro won the David E. Bright Foundation prize for a sculptor under 45; Richard Smith won the Mr and Mrs Robert C. Scull prize for a non-American artist under 35.
Norman Reid was on the International Jury.

British Pavilion
Selection Committee:
Sir Philip Hendy, Alan Bowness, Sir Herbert Read, David Thompson, Lilian Somerville.

Commissioner:
Lilian Somerville.

Five Young British Artists:
Bernard Cohen
Harold Cohen
Robyn Denny
Anthony Caro
Richard Smith

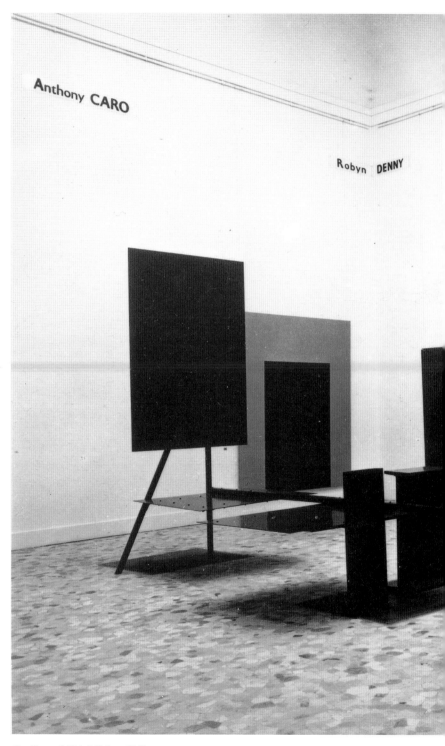

Anthony CARO

Robyn DENNY

Five Young British Artists exhibition.
Sculpture by Anthony Caro, paintings by Robyn Denny (left) and Harold Cohen

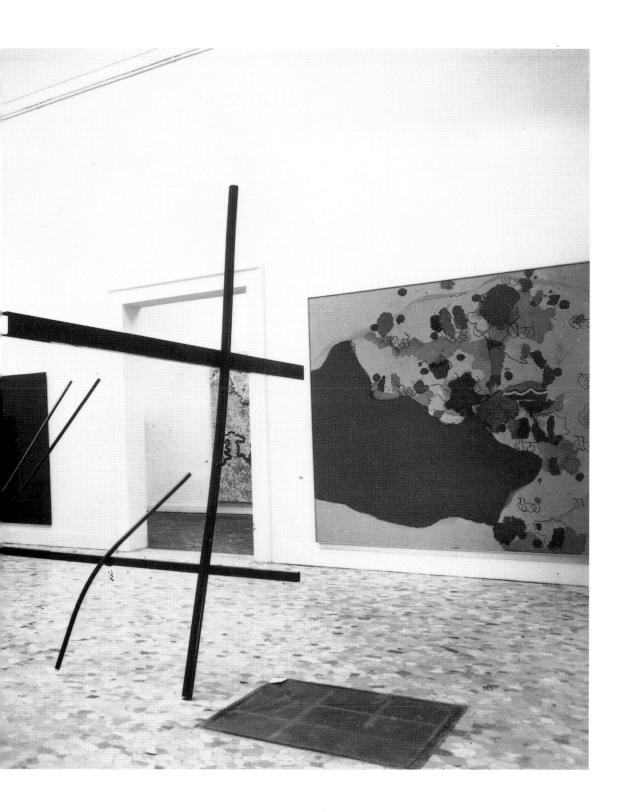

Bridget Riley won the
International Painting
Prize.

British Pavilion
Selection Committee:
Norman Reid, Alan
Bowness, David
Thompson, Lilian
Somerville.

Commissioner:
Lilian Somerville.

**Phillip King
Bridget Riley**

*Ways of
contemporary
research*
included Francis Bacon,
Anthony Caro, David
Hockney, Ben Nicholson,
Eduardo Paolozzi, Victor
Pasmore, Graham
Sutherland [Not listed in
catalogue; opened 10th
August]

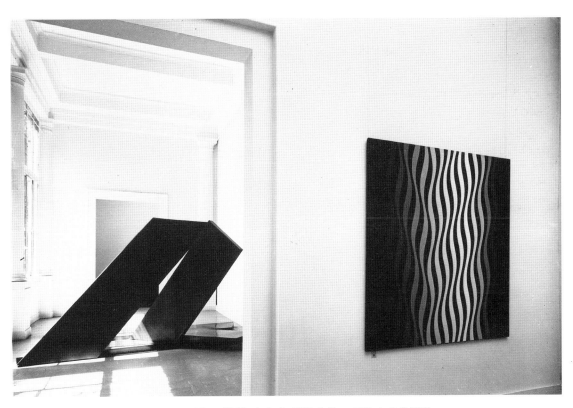

(1968) Exhibition of Phillip King and Bridget Riley with King's *Brake* 1966 (left), and Riley's *Drift* 1966

35 1970

British Pavilion

Selection Committee:
Norman Reid, Alan
Bowness, Norbert Lynton,
David Thompson, Lilian
Somerville.

Commissioner:
Lilian Somerville.

Richard Smith

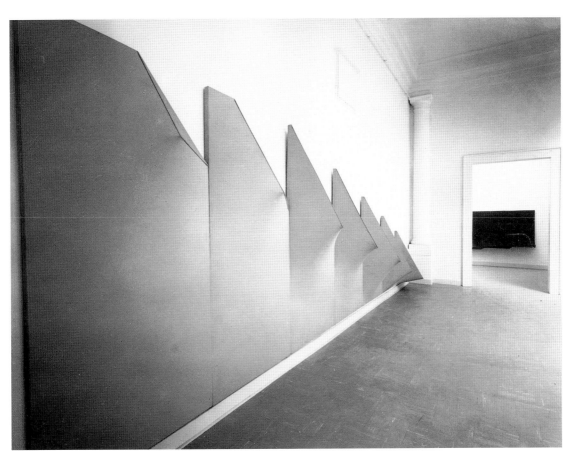

(1970) Richard Smith exhibition showing *Clairol Wall*, 1967 (left)

British Pavilion
Selection Committee:
Norman Reid, Alan
Bowness, Guy Brett,
Norbert Lynton, John
Hulton.

Commissioner:
John Hulton (Director,
Fine Arts Department,
British Council).

John Walker
William Tucker

*Grafica sperimentale
per la stampa*
Michael English, John
Gorham, F. H. K. Henrion*,
Lou Klein*, Pentagram
(Alan Fletcher*, Colin
Forbes, Mervyn
Kurlansky*), Enzo
Ragazzini*

*Il libro come luogo di
ricerca*
including Victor Burgin,
Hamish Fulton, Gilbert*
and George, Brion Gysin**

Video-nastri
including Barry Flanagan,
Richard Long, Gilbert and
George

Pérsona 2
including Gilbert and
George, John Lennon

*Venezia: ieri, oggi,
domani*
James McBey, Ben
Nicholson, Graham
Sutherland

Sculture nella città
Anthony Caro

Grafica d'oggi
Ian Colverson, Alan Davie,
Jeffery Edwards, Allen
Jones, Ronald Kitaj[11],
Henry Moore, Victor
Pasmore, Tom Phillips,
Ceri Richards, William
Tillyer

[11] At the 1970 Biennale Kitaj
had shown in the American
Pavilion and in 1972 is listed as
American.

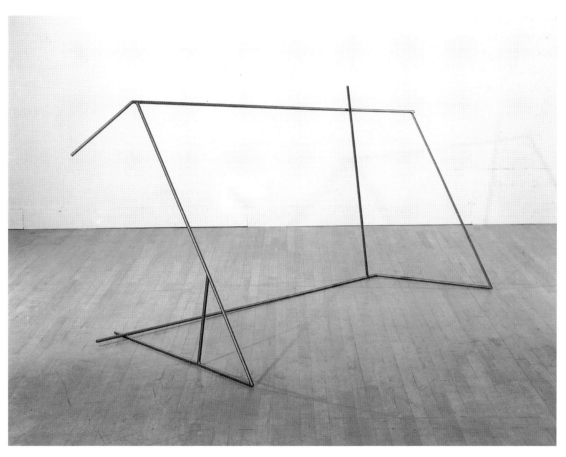

(1972) William Tucker, *Cat's Cradle,* 1971, steel, 122 x 325 cm, Arts Council Collection, The South Bank Centre, London
(photograph not taken in Venice)

123

1976

British Pavilion
Selection Committee: Peter
Lasko, Michael Compton,
Gerald Forty.

Commissioner:
Gerald Forty (Director,
Fine Arts Department,
British Council).
Assistant Commissioner:
Muriel Wilson.

Richard Long

*Ambient/Art
exhibition*
Victor Pasmore and
Richard Hamilton

Europe-America
*[a contemporary
architecture exhibition]*
David Mackay**
Alison and Peter Smithson
James Stirling

*International Events
'72-'76*
John Davies
Philip Hyde, Anne
Rawcliffe-King and
Yolanda Teuten

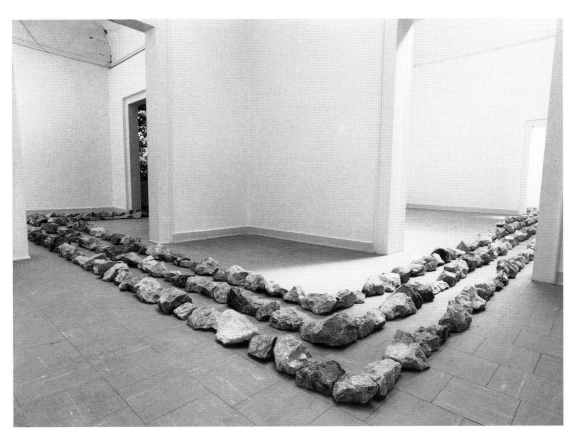

(1976) Richard Long exhibition

British Pavilion
Commissioner:
Gerald Forty.
Assistant Commissioners:
Julian Andrews, David
Fuller.

[From this date a Selection
Committee for Venice was
no longer formally named
in the catalogue, but a sub-
committee of the British
Council's Fine Arts
Advisory Committee
continued to make the
selection.]

Mark Boyle

*Six Stations for Art-
Nature. The Nature of
Art*
Malcolm Morley**
Francis Bacon
David Hockney
Richard Long
Gilbert and George

Art and Cinema
Anthony McCall

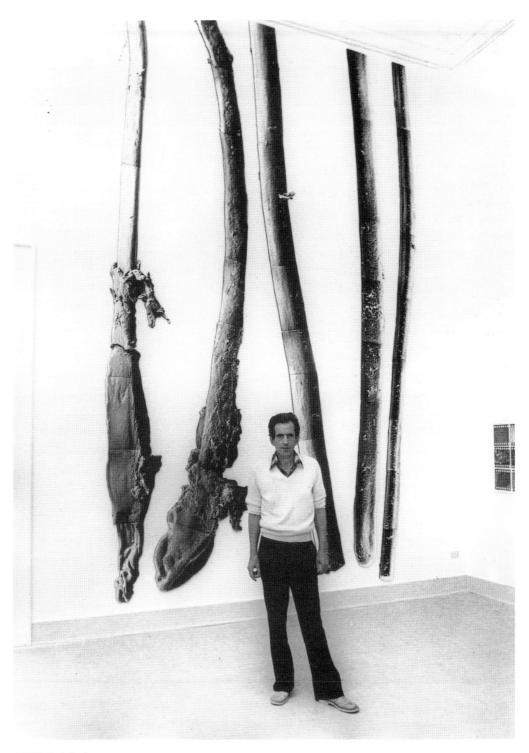

(1978) Mark Boyle

Michael Compton was on the Visual Arts Commission.

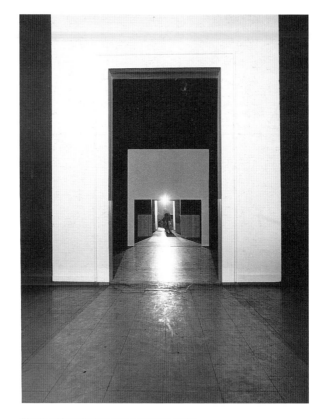

British Pavilion
Commissioner:
Gerald Forty.
Assistant Commissioners:
Ian Barker, Henry Meyric Hughes.

Tim Head
Nicholas Pope*

Art in the Seventies
Richard Long, Bruce McLean, Kenneth Martin 'Television Exhibitions' –

Barry Flanagan, Richard Long, Hamish Fulton, Gilbert and George

Art in the Seventies. Open 80 [Aperto 80]
Roger Ackling, Tony Cragg**, Leonard McComb

Tim Head installation: *Day and Night*, **1980**

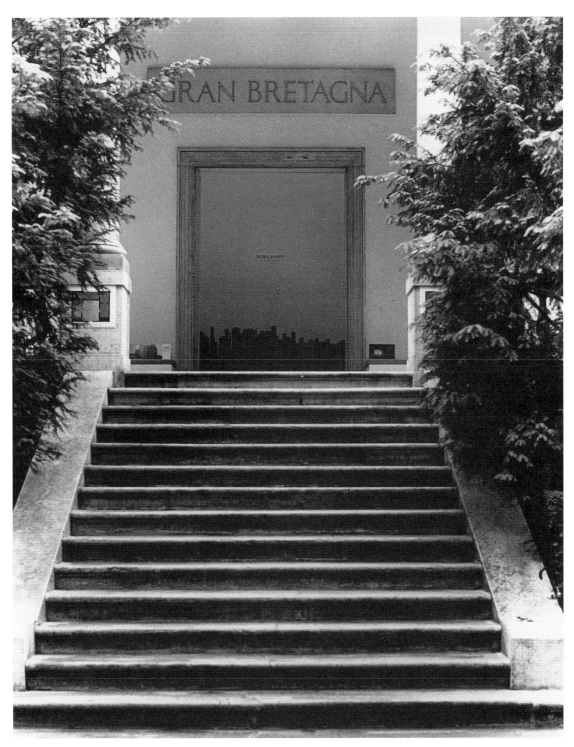

(1980) Entrance to the British Pavilion with Nicholas Pope's *Long Larch Line*, 1980

British Pavilion
Commissioner:
Julian Andrews (Director,
Fine Arts Department,
British Council).
Assistant Commissioner:
Teresa Gleadowe.

Barry Flanagan

*Arte come arte:
persistenza dell'opera
– Mostra
internazionale*
Frank Auerbach*,
Raymond Mason**, Lucian
Freud, Ronald Kitaj

Aperto 82
Catherine Blacker,
Stephen Cox, Antony
Gormley, Tim Head, Anish
Kapoor*, Judy Pfaff**[12], Bill
Woodrow, Shirazeh
Houshiary*, Christopher
Le Brun, Stephen Willats

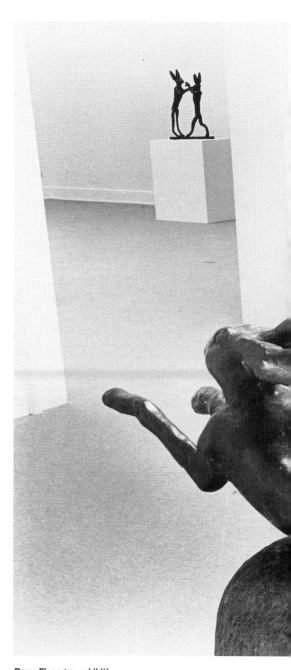

Barry Flanagan exhibition

[12] Shown in 1980 in the U.S.
Pavilion.

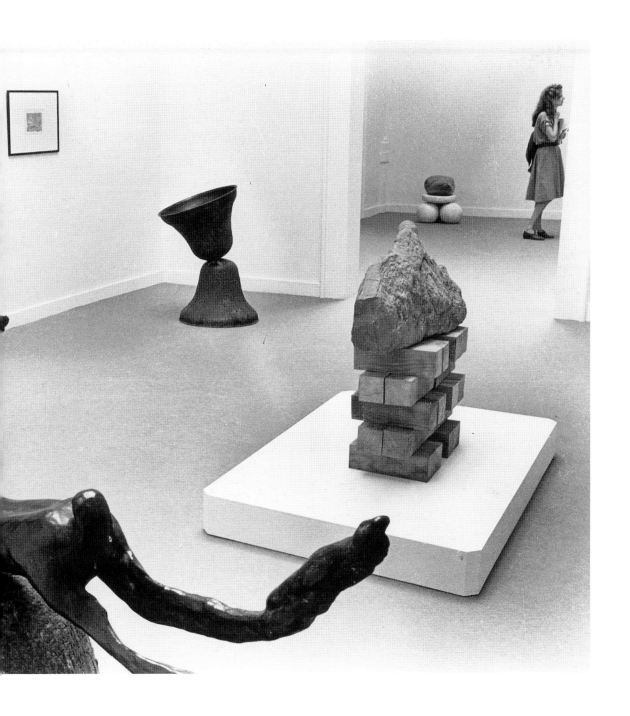

41 1984

British Pavilion
Commissioner:
Julian Andrews.
Assistant Commissioner:
Teresa Gleadowe.

Howard Hodgkin

Arte allo Specchio
Peter Greenaway
Christopher Le Brun

Arte, Ambiente, Scena
Judy Pfaff

Aperto 84
Terry Atkinson, Helen
Chadwick, Rose Garrard,
Glenys Johnson, Paul
Richards, Amikam Toren*,
Kerry Trengove

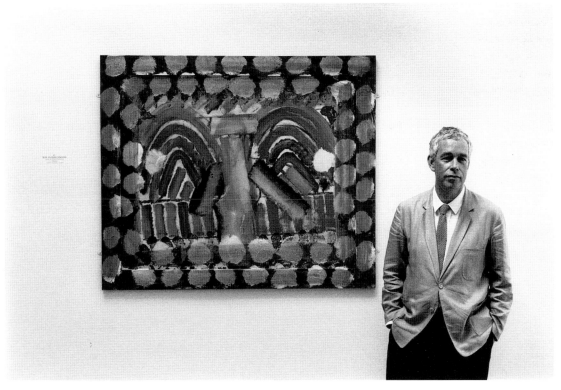

(1984) Howard Hodgkin with *D.H. in Hollywood*, 1980-84

42 1986

Frank Auerbach shared the Leone d'Oro prize for the best artist with Sigmar Polke.
Alan Bowness was a member of the Jury.

British Pavilion
Commissioner:
Henry Meyric Hughes (Director, Fine Arts Department, British Council).
Assistant Commissioners: Jacqueline Ford, Malcolm Hardy.

Frank Auerbach

Aperto 86
Lisa Milroy*, John Murphy, Avis Newman, Jacqueline Poncelet*, Boyd Webb*, Richard Wilson

Arte e Scienza
Thomas Major (1714-1799), Conroy Maddox, Allen Jones, Ithell Colquhoun, Leonora Carrington, Alison Wilding, Antony Gormley, Eric Bainbridge, Joscelyn Godwin**, Stephen Cox, Philip West**, Hugh O'Donnell, Alastair Brotchie*, Neil Cummings, Barry Flanagan, Tony Cragg, Kurt Schwitters* [died England], Kenneth Martin, Peter Sedgley**, Bridget Riley, Alastair Morton, Jeffrey Steele, Mary Martin, Anthony Caro, Peter Lowe, Brian Eno, Liliane Lijn*, Andrew Owens, Eric Gidney**, Paul Hayward**, Mike Punt and Kyeran Lyons, Paul

Thomas**, Digital Pictures, Jeremy Gardiner**

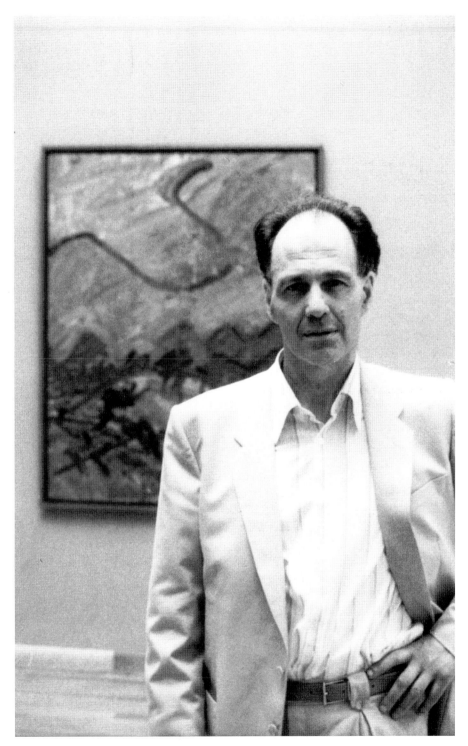

(1986) Frank Auerbach with *Primrose Hill*, 1980

Tony Cragg was awarded a special mention.
David Sylvester was a member of the Jury.

Tony Cragg

British Pavilion
Commissioner:
Henry Meyric Hughes.
Assistant Commissioners:
Malcolm Hardy, Ann
Elliott.

Scultori ai Giardini
Lynn Chadwick, Anthony
Caro, Phillip King, Joe
Tilson

Aperto 88
Tony Bevan, Hannah
Collins, Grenville Davey,
Andy Goldsworthy, Simon
Linke*, Peter Nadin**,
Thomas William Puckey**

(1988) Tony Cragg exhibition: *Generations*, 1988, *Policeman*, 1988 at rear

Anish Kapoor won the
Premio Duemila for the
work of a young artist.
Richard Francis was a
member of the Jury.

British Pavilion
Commissioner:
Henry Meyric Hughes.
Deputy Commissioners:
Brett Rogers, Malcolm
Hardy.

Anish Kapoor

*Three Scottish
Sculptors*
David Mach, Arthur
Watson, Kate Whiteford

Aperto 90
Eric Bainbridge, David
Leapman, Patrick Joseph
McBride, Therese Oulton,
Fiona Rae, Anthony Wilson

Fluxus exhibition
included Dick Higgins**,
Peter Moore**, Robin
Page**, Braco Dimitrijevic*,
Brion Gysin [died 1986]

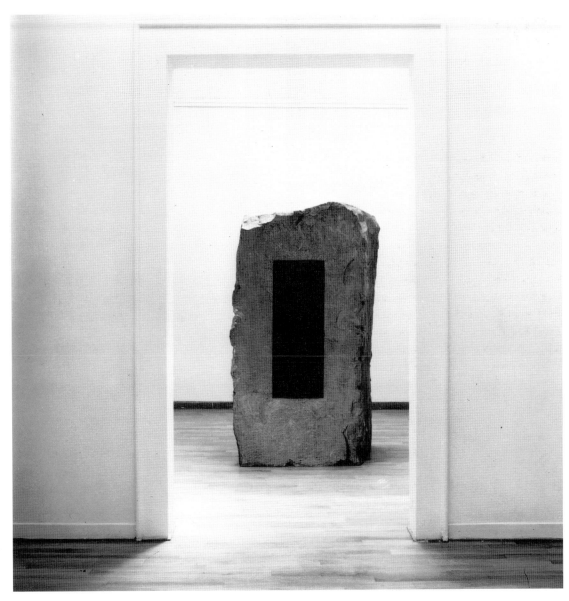

(1990) Anish Kapoor exhibition showing *It Is Man*, 1989-90

45 1993

Richard Hamilton shared the Leone d'Oro for the best artist with Antoni Tàpies. David Sylvester was awarded a Leone d'Oro (Giulio Carlo Argan prize) for art criticism. Nicholas Serota was a member of the Jury.

British Pavilion

Commissioner:
Andrea Rose (Head, Visual Arts Department, British Council).
Deputy Commissioners: Brendan Griggs, Gill Hedley.

Richard Hamilton

Aperto 93

Christine Borland, Mat Collishaw, Damien Hirst, Simon Patterson, Vong Phaophanit*, Steven Pippin, Julie Roberts, Georgina Starr, Angela Bulloch*, Henry Bond

Punti dell'arte

Anish Kapoor

Slittamenti

Peter Greenaway, Derek Jarman

Figurabile: Omaggio a Francis Bacon

Macchine della pace

Tony Cragg, Shirazeh Houshiary, Julian Opie

La coesistenza dell'arte

Braco Dimitrijevic

Art against Aids. Venezia 93

Frank Auerbach, Tony Cragg, Richard Deacon, Braco Dimitrijevic, Gilbert and George, Shirazeh Houshiary, Anish Kapoor, Ronald Kitaj, Malcolm Morley, Ray Smith, Rachel Whiteread

Trésors de voyage

Braco Dimitrijevic, Anish Kapoor, Shirazeh Houshiary

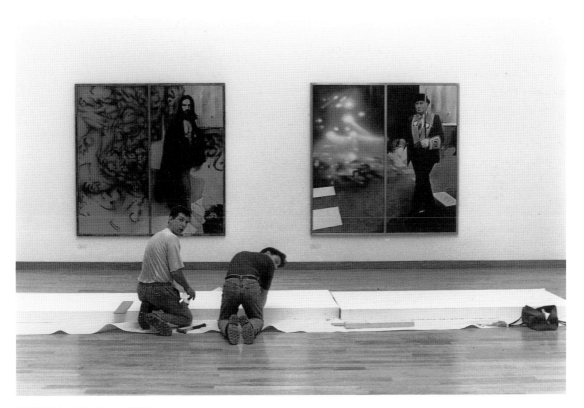

(1993) Richard Hamilton exhibition

British Pavilion
Commissioner:
Andrea Rose.
Deputy Commissioners:
Brendan Griggs, Richard
Riley.

Leon Kossoff

Scuola San Pasquale
General Release: Young
British Artists
Fiona Banner
Dinos Chapman
Jake Chapman
Adam Chodzko
Matthew Dalziel and
 Louise Scullion
Ceal Floyer
Tom Gidley
Douglas Gordon
Gary Hume
Jaki Irvine
Jane Wilson and
 Louise Wilson
Elizabeth Wright
Cerith Wyn Evans
and in the catalogue: Lucy
Gunning, Sam Taylor-
Wood, Tacita Dean

[At the time of going to
press the names of British
artists in other sections of
the Biennale had not yet
been announced.]

(1995) Leon Kossoff, *Christchurch Spitalfields, Spring,* 1987, oil on board, 61.5 x 56 cm, British Council Collection, London

143

Anthony Caro in the British Pavilion in 1966

List of Catalogue Texts and Further Reading

List of catalogue texts on Artists shown in the British Pavilion at Venice
(these texts appear in catalogues and pamphlets published by the British Council, except where noted as appearing in Venice Biennale catalogues if this differs)

Catalogue texts

1932: unsigned text in the Biennale catalogue.

1934: text by Major Alfred Longden in the Biennale catalogue.

1938: *British Exhibit. List of pictures and sculpture in the British Pavilion*, 21st International Biennale Exhibition of Fine Arts, Venice, [no text], typescript produced by the British Council; also texts in the Biennale catalogue by Kenneth Clark on Jacob Epstein, Matthew Smith, Paul Nash, Stanley Spencer and Christopher Wood, and by Campbell Dodgson on Blair Hughes-Stanton and Stanley Anderson.

[1940: *The Works of Six Contemporary British Artists together with a collection of Modern Wood Engravings*, British Council catalogue of the exhibition of the works selected for inclusion in the 1940 Biennale and withdrawn at a late stage. With an unsigned introduction. Exhibition held at Hertford House, London (the Wallace Collection), 17 May – 8 June.]

1948: text on Turner by John Rothenstein, and on Henry Moore by Herbert Read.

1950: text on Constable by Eric Maclagan, on Matthew Smith by John Rothenstein, and on Barbara Hepworth by David Lewis.

1952: text on Graham Sutherland by Kenneth Clark, on Edward Wadsworth by Philip Hendy, and on 'New Aspects of British Sculpture' by Herbert Read.

1954: text on Ben Nicholson by Herbert Read, on Francis Bacon by David Sylvester, and on Lucian Freud by John Rothenstein.

1956: text on Ivon Hitchens by Patrick Heron, on 'Four Young Painters' by J. P. Hodin, and on Lynn Chadwick by Robert Melville.

1958: text on William Scott, Kenneth Armitage and S.W. Hayter by Herbert Read.

1960: text on Victor Pasmore by Alan Bowness, and on Eduardo Paolozzi by Robert Melville.

1962: text on Ceri Richards by John Russell, on Robert Adams by J. P. Hodin, and on Hubert Dalwood by Norbert Lynton.

1964: texts on Roger Hilton, Bernard Meadows, Gwyther Irwin and Joe Tilson by Alan Bowness.

1966: text on Bernard Cohen, Harold Cohen, Robyn Denny, Anthony Caro and Richard Smith by David Thompson.

1968: text on Phillip King by Bryan Robertson, and on Bridget Riley by David Thompson.

1970: introduction derived from a conversation with Richard Smith.

1972: text on John Walker by John Elderfield, and on William Tucker by Andrew Forge.

1976: text on Richard Long by Michael Compton.

1978: text on Mark Boyle by Michael Compton.

1980: texts on Tim Head and Nicholas Pope by Norbert Lynton.

1982: texts on Barry Flanagan by Tim Hilton and Michael Compton, and chronological text by Alexandra Pringle; and text by Teresa Gleadowe in the British Council pamphlet.

1984: text on Howard Hodgkin by John McEwen, and an interview

with Hodgkin by David Sylvester; text by Teresa Gleadowe in the British Council pamphlet; and by Nicholas Serota in the Biennale catalogue.

1986: text on Frank Auerbach by Catherine Lampert; by Jacqueline Ford in the British Council pamphlet; and by Richard Cork in the Biennale catalogue.

1988: texts on Tony Cragg by Demosthenes Davvetas and Catherine Lampert; and by Ann Elliott in the Biennale catalogue.

1990: text on Anish Kapoor by Thomas McEvilley, and an interview with Kapoor by Marjorie Allthorpe-Guyton.

1993: texts on Richard Hamilton by Sarat Maharaj; by Richard Cork in the British Council pamphlet; and by Richard Morphet in the Biennale catalogue.

1995: texts on Leon Kossoff by Andrea Rose, David Sylvester, Rudi Fuchs and Leon Kossoff himself; texts on the Young British Artists by James Roberts and Gregor Muir.

Further reading

La Biennale di Venezia. Storia e Statistiche, with contributions from Maraini, Bazzoni, Zorzi, Varagnolo, Lualdi and de Feo, Venice, n. d. [c.1932].

Douglas Cooper, 'Reflections on the Venice Biennale', *The Burlington Magazine*, October 1954, no. 619, vol. XCVI, pp. 317-322; reply by Rodolfo Pallucchini, and counter-reply by Cooper, March 1955, no. 624, vol. XCVII, pp. 85-7.

Romolo Bazzoni, *60 Anni della Biennale di Venezia*, Venice, 1962.

Charles S. Spencer, 'Venice Biennale: choosing the artists', and David Thompson, 'Venice Biennale: the British five', *Studio International*, London, vol. 171, no. 878, June 1966.

Texts on the Biennale by Jasia Reichardt, Alan Bowness, David Thompson and Ann Turner, in *Studio International*, vol. 172, no. 880, August 1966.

Hugh Honour, 'Biennales of Other Days: A Cautionary Tale', *Apollo*, July 1966, vol. LXXXIV, no. 53, pp. 24-33.

Lawrence Alloway, *The Venice Biennale 1895-1968. From Salon to Goldfish Bowl*, London, 1968. Wladimiro Dorigo, 'Lineamenti

bibliografici generali sulla Biennale di Venezia' [1887-1974], *La Biennale di Venezia. Annuario 1975. Eventi del 1974*, Venice, 1975, pp. 707-711.

Giandomenico Romanelli, *Ottant'anni di architettura e allestimenti alla Biennale di Venezia*, Venice, 1976; (extracted from *La Biennale di Venezia. Annuario 1975. Eventi del 1974*, a cura dell' Archivio Storico delle Arti Contemporanee, Venice, 1975, pp. 645-668, and *La Biennale di Venezia. Annuario 1976. Eventi del 1975*, 1976, pp. 785-896).

Giandomenico Romanelli, *Ottant'anni di allestimenti alla Biennale*, (catalogue of an exhibition at Ca' Corner della Regina, December 1977-January 1978), La Biennale di Venezia, Archivio Storico delle Arti Contemporanee, Venice, 1977.

Paolo Rizzi and Enzo Di Martino, *Storia della Biennale, 1895-1982*, Milan, 1982.

Ragna Nesta Margaret Garlake, *The Relationship between Institutional Patronage and Abstract Art in Britain c.1945-1956*, Ph.D., Courtauld Institute of Art, University of London, 1987.

Guiliana Donzello, *Arte e collezionismo. Fradeletto e Pica primi segretari alle Biennali veneziane 1895-1926*, Florence, 1987.

Marco Mulazzani, *I Padiglioni della Biennale. Venezia 1887-1988*, Milan, 1988.

Britain and the São Paulo Bienal 1951-1991, The British Council, 1991.

Jude Burkhauser, '"Sala M" Arte Decorativa Scozzese. Charles Rennie Mackintosh and the Glasgow Group at the Venice Biennale Exhibition of 1899', *Charles Rennie Mackintosh Society Newsletter*, Glasgow, no. 58, Spring 1992.

Philip Rylands and Enzo Di Martino, *Flying the Flag for Art. The United States and the Venice Biennale 1895-1991*, Richmond, Virginia, 1993.

(Forthcoming) Shearer West, 'National Desires and Regional Realities in the Venice Biennale 1895-1914', *Art History*, December 1995.

Archives

Archives at the British Council, Public Record Office, Kew and Archivio Storico delle Arti Contemporanee, Venice.

Acknowledgements

The staff of the Visual Arts
 Department, The British
 Council, London
Beatrice Alleyne
Philip Attwood
La Biennale di Venezia, Archivio
 Storico delle Arti
 Contemporanee: Daniela
 Ducceschi and Sergio Pozzati
Roger Billcliffe
Alan Bowness
The British Consulate, Venice
Judith Bronkhurst
Browse & Darby
Courtauld Institute of Art,
 University of London
Kathy Culpin
Gustave Delbanco
Joan Denvir
Rachel Duffield
William Féaver
Anne French
Norah C. Gillow
Kay Gimpel
Brendan Griggs
Kate Hazlehurst
Gill Hedley
Beth Houghton
Anne James
David Fraser Jenkins
Sheila McGregor
Margaret McLeod
Victorine F.- Martineau
Fiona Mayle

Judith Monk
William Packer
Lucio Passerini
Andrew McIntosh Patrick
The Rev. Canon A. C. J. Phillips
Louis Pirenne
George Rawson
Alex Robertson
Tiggy Sawbridge
David Scrase
Julian Stallabrass
Anthony Stokes
Tate Gallery Archive
E. Topliffe
Ann Turner
Felicitas Vogler
Sue Webster
Angela Weight
Robert Wenley
Shearer West
Stephen Whittle
Sarah Wimbush

INDEX

Name index to artists, committee members, and others included in the chronological list of British artists, and to artists and writers included in the 'list of catalogue texts'.

The number following a name indicates that the person was included or involved in that particular Biennale, e.g.:

Sutherland, Graham 26 (two)

indicates that Graham Sutherland was included in the twenty-sixth Biennale, and that his name appears twice in that year of the chronological list. Similarly:

Read, Herbert 22, 33; text

indicates that Herbert Read was involved in the twenty-second and thirty-third Biennales and that there is a text by or about him in the 'list of catalogue texts'.

Index: Britain at the Venice Biennale 1895-1995